Conor
Drawing from Life

Jonathan Bell

Appletree Press

First published in 2002 by
Appletree Press Ltd
The Old Potato Station
14 Howard Street South
Belfast
BT7 1AP

Tel: +44 (0) 28 90 243074
Fax: +44 (0) 28 90 246756
Web Site: www.appletree.ie
E-mail: reception@appletree.ie

Conor – Drawing from Life

A catalogue record for this book is available from the
British Library.

ISBN 0 86281 847 8

Commissioning & General Editor: Paul Harron
Design by Stonecastle Graphics

9 8 7 6 5 4 3 2 1

Half-title page illustration: see p.95
Title page illustration: see p.62

Contents

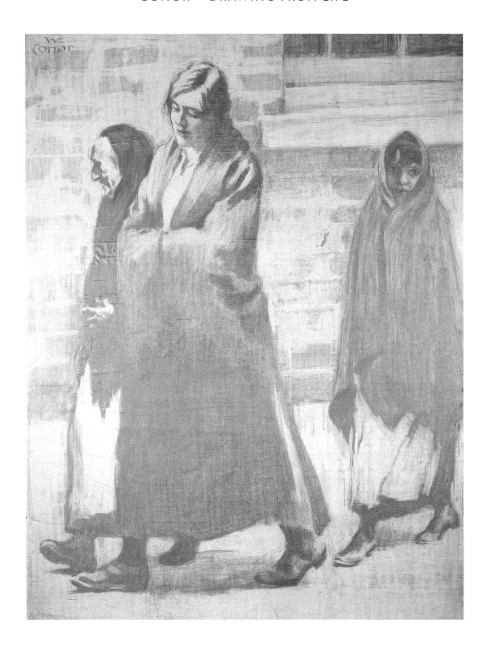

Introduction

THIS BOOK has two main subjects: the artist William Conor and the city of Belfast. Conor shaped the way that Belfast people saw themselves and their city. His paintings of shawlies, shipyard workers and happy children are as familiar to many Northern Irish people as Constable's *Haywain* or Van Gogh's *Sunflowers*. The best-known paintings, however, represent only a tiny part of his output. The Ulster Folk and Transport Museum has well over 2000 works by Conor. Some of these are preparatory drawings for big paintings, but there are also many tiny sketches, which record a moment in time as observed by the artist. This book centres on these smaller works, both as beautiful drawings, and as a wonderful record of the everyday world in which Conor lived.

Conor was a city man. He drew and painted rural scenes and people, but the great bulk of his work shows the people of Belfast; his own family, workmates and people on the city's streets. Their southern counterparts appear in the writings of James Joyce and Sean O'Casey rather than W.B. Yeats or J.M. Synge; respectable office workers and housewives, as well as street hawkers and music hall *artistes*.

The city in which these people lived was an industrial giant, a world power in textiles, ship-building, ropemaking and tobacco processing. It was also a place where oppressive poverty and communal violence were central elements of the social world. The great, troubled urban sprawl provoked many critical comments, from visitors and its own inhabitants. The human warmth of its people, however, also inspired great love, and it is this above all which shines through Conor's work.

Left: **Going to the mill (c.1930)**

Conor eulogised the shawl as bringing out beauty and personality. However, this careful drawing powerfully portrays the grind of working class life.

Conor – Drawing from Life

WILLIAM CONOR was the artist who provided many Belfast people with the most enduring images of life in their city during the first half of the twentieth century. Conor's central contribution to the visual arts in Ulster during the period has been well examined and discussed by both contemporaries and more recent commentators[1]. The main aim of the present publication, however, is to examine Conor's role as a chronicler of the daily life of people in Belfast and surrounding areas, mainly in the period 1904–1920, as illustrated in his pencil, ink, and crayon sketches.[2]

All of the drawings included are preserved in the Ulster Folk and Transport Museum (MAGNI), where the collection contains around one thousand five hundred pencil sketches made by Conor. For some years these were preserved in the Linen Hall Library, Belfast, where they were examined by John Hewitt, who recorded his impressions, in 1977:

There are hundreds of drawings of people, with pages of details of feet, hands, heads, as well as horses, and a few sketches of landscape, mostly of the Lagan. By good fortune, some carry dates, the earliest being 1904, with the bulk of those dated coming from the period 1906 to 1910. These drawings made in the city markets and parks, or at race meetings (Lisnalinchy Races 1910), vary in quality and kind, some simple notes, others carefully executed… Not on drawing paper of good texture, but small pieces, as if torn from a jotter, they could well be those he made behind a folded newspaper, not to disconcert his subjects, as he wandered round the streets.[3]

An examination of the sketches in the museum collection leaves the impression of detached scrutiny, rather than impassioned engagement. To some extent this arises from the variety of

Right: **Self portrait (c.1925)**

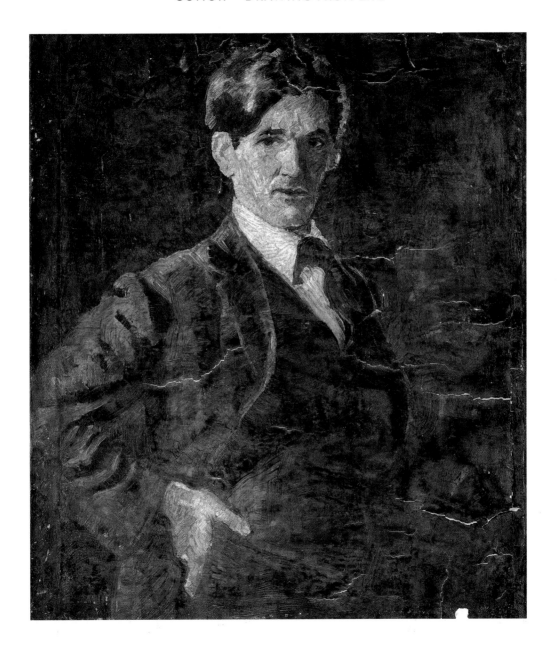

subjects included, and their apparently arbitrary juxtaposition, pointed out by Hewitt. Drawings of stair banisters may appear alongside studies of horses' feet or portrait studies, for example, all apparently recorded with the same attention. Distance between the artist and his human subjects is also suggested by the lack of awareness of many people that they were in fact being sketched. Conor's drawings constitute a valuable record of everyday life in the period, not only because of his skilled draughtsmanship, but also because of the unstudied context in which they were made. In the early 1900s,

> Conor was…developing a spontaneous drawing technique by recording quick impressions, and it soon became a habit for him to…go out into the streets with a newspaper, which contained loose leaves from his sketchbook. When he saw anything of interest he leant against a lamp post or wall, took out his newspaper as though he were simply reading the sports results and sketched away.[4]

Large numbers of the people represented are shown turned away from the viewer, in side views, three quarters, or even full back. This gives a shy, almost surreptitious quality to many of the sketches, and also reduces the possibility of concentration on the subjects' characters.

> When Conor's idiosyncratic figures find themselves brought together in a drawing or painting, it is as if the spectator, the observer, were eavesdropping, overhearing some snatch of conversation, some tatter of gossip, badinage, rumour or song, some brief word of greeting, of endearment or comfort.[5]

This detachment between artist and many of his subjects was not unique to Conor. T. P. Flanagan has pointed that Conor's drawings belong to a period when similar graphic representations of everyday life were regularly undertaken by illustrators working for newsapers and periodicals. Kenneth Jamison has suggested that many of the sketches were intended as *aides-memoirs*, and their dispassionate detachment can be paralleled in similar works by many artists and illustrators.[6] When we examine the dawings as representations of everyday reality, the detachment between artist and and many of his subjects is interesting,

because it means that we are looking at the artist's view of observed reality, rather than a reality which is also mediated by the way in which human subjects presented themselves to the artist. John Hewitt has pointed out, however, that Conor, like any artist, was a selector as well as a recorder of everyday life, and it is worthwhile to attempt to identify the concerns underlying his selection of subjects.

Politically, Conor was a Unionist, who seems to have had no difficulty in also accepting that he was Irish. This was a fairly common position in the early years of the twentieth century when many northern Unionists accepted symbols of Irishness such as shamrock and interlaced patterns, as the equivalent of thistles and tartan in Scotland, or red dragons and daffodils in Wales. Awareness of the creative ferment produced by the Celtic Revival probably led Conor to begin spelling his surname with one 'n' rather than two. Around this time, he even signed some of his work using a 'Gaelicised' form, Liam Ó Concohair, for a short period. He also made pilgrimages to the Blasket Islands, and to Donegal, although he does not seem to have experienced the life changing revelations there, reported by artists such as Paul Henry.

Conor's work during the First World War displayed a strong attachment to Britain, and especially to British Ulster. In 1916, he made an illustration of the charge of the Ulster Division at Thiepval. Prints and postcards were made from this, and the proceeds went to the UVF hospital. The same attachment can be seen in his painting of the opening of the Northern Ireland Parliament in 1921, by King George V and Queen Mary, although Kenneth Jamison has pointed out that this may also have been the result of his awareness of the achievements of John Lavery and William Orpen in recording similar events, and a desire to emulate these.[7] During the Second World war, an invitation from the Ministry of Information, in 1940, to produce a series of drawings showing Northern Ireland's contribution to the war effort, gave a further opportunity for Conor to express his loyalty to Britain. In a letter to the Ministry, he confided, 'It has been a gratification to me that I have been permitted to show a wide audience the great deeds that have been performed by my fellow countrymen in defence of freedom'[8].

Throughout his adult life contemporaries noted how Conor also emphasised his Presbyterian background, apparently not so much as a

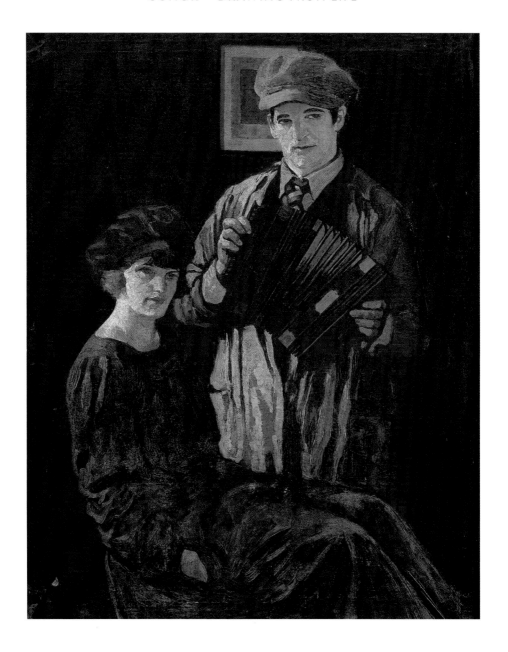

religious belief, as a badge of belonging. A friend, William Carter, commented, 'There was William Conor the Presbyterian and his alter ego William Conor the agnostic. William's frequent declarations of his Presbyterianism were to identify the tradition into which he had been born and because he was sensitive that his 'papish' appearance and name led those who did not know him to think that he dug with the wrong foot'.[9]

Conor's political position gives us some understanding of specialised areas of output, such as wars and state occasions, but the lifelong central theme of his painting was undoubtedly the celebration of everyday life in Belfast and its surrounding regions, and the question arises whether this was driven by some artistic, or ideological programme. Conor's recorded discussion of these issues was not elaborate, to the disappointment of critics such as John Hewitt, who commented that Conor

Left: **The Studio Dance (1924)**

This early self portrait shows Conor playing a button accordion. This was probably artistic licence as he was alleged to be tone deaf.

was 'no intellectual, no aesthetician',[10] but some comments do give us an insight into his view of art, and its social significance. He seems to have had a Platonic ideal of beauty, combined with an un-Platonic belief in the central importance of art. In an interview in *Ireland's Saturday Night* in 1962 he stated, 'There is no justification for life without art…It is my belief that beauty is never completely absent from the activities of human life'.[11] In his Presidential address to the Royal Ulster Academy, he commented that 'Art exists only when things are made to last for ever'[12]. Discussing his choice of subjects, he commented, 'My aim is to seek for beauty in those places where it is not often sought, in crowded thoroughfares, in the factory, in the shipyard'.[13] The emphasis in his work on working class people arose from an 'ambition to reveal the Spiritual character of [Belfast]… people in all [its] vigour, in all its passion, humanity and humour'.[14] However, this was not related to any social programme. In a radio interview broadcast in 1961, he commented,

I'm not interested in social questions at all. I just want to express my fellow men and women as I see them I have no…social message, like Hogarth, for instance. He was

very interested in the social conditions in which the poor people lived in his time. I'm not particularly interested in that… [Humble people] are more interesting in their clothing and their methods of living – much more interesting than the better classes…When I was in London, I tried to express the people at Hampstead Heath – made drawings and paintings of them then, but I found I wasn't getting beneath the surface, as I could at home. At home, I was one of the people, and I knew the variety of their passions and living…and I felt I could interpret them for that very reason. And I like them, besides.[15]

John Hewitt has made some sharp comments about the lack of social engagement in Conor's work. 'He was just a proletarian artist. There was neither protest nor thought about it…Time and time again looking through a book of [the socialist artist, Kaethe] Kollwitz's drawings, you find similarities to William Conor. But there is one difference. She had a social conscience, and that's what gives an edge and a sharpness and a strength to her work which is missing in his.'[16] The artist Mercy Hunter, a very close friend of Conor's, speaking in the same radio

programme, might have added unintentionally to the view that Conor's representations of working class life lacked substance, when she commented, 'He was a happy man and he painted things happily. And even if he was painting poverty, it was a sort of happy poverty'.[17]

In his drawings, Conor certainly avoided many realities faced by working class people, such as oppressive working conditions, unemployment, and sickness. He also avoided the negative aspects of working class culture. His drawings and paintings do not record drunkenness, street fights, or wife beating, which it was claimed, characterised the lifestyle of the 'rough' working class of Belfast during the early twentieth century.[18] However, it would be wrong to see his work as sanitised or sentimental. Rather, as Brian Kennedy states, he presents 'a robust, optimistic outlook on life.'[19] For Kenneth Jamison, Conor's work benefited from its lack of explicit social message. 'He is, perhaps, a kind of Irish Daumier, but without the bitter satirical edge; certainly an impressionist of sorts whose affection for his subjects saved him from becoming doctrinaire'.[20] Jamison, in contrast to Hewitt, sees many similarities between

Kollwitz's drawings and Conor's. In part, he suggests that this is due to their common experience of working with lithographer's crayons. He also suggests that that the highly charged social comment and protest found in Kollwitz's work, and relatively lacking in Conor's, may be due to the different social forces which moulded the two artists and the societies in which they lived, rather than any lack of ideological commitment on Conor's part.[21] John Hewitt, despite his disappointment at Conor's lack of explicit commitment to social issues, nevertheless celebrated his vision of working class life in a poem.

> You Conor, were the first of painting men
> whose art persuaded my young eyes to see
> the shapes and colours which give quiddity
> to the strange bustling world about me then;
> and if I recall those days again,
> yours are the shadows which accompany me
> the shawled girls linked and stepping
> measuredly
> the heavy footed tread of Islandmen.
> But now the years have blown that world
> away,
> and drugged our days and dreams with
> violence,

> your loaded canvasses may still provide,
> in face of fear and hate, brave evidence
> our people once knew how to pray and play,
> and, laughing, take life's buffets side by side.[22]

All of this helps us to understand the subject matter of the pencil drawings which deal with working class life. However, it is also important to emphasise that many of Conor's most detailed surviving drawings, show the life of skilled artisans and the lower middle, rather than the working class. The lower middle class subjects are not only some of the most carefully executed, but also approach intimacy more closely than anything else in his work; people sleeping or reading, or in one case, suffering from a toothache. This was the social world in which Conor, his family, and workmates lived, and the careful execution of the works reflects the ready availability of subjects to which this gave rise. The world evoked is very close to that described in James Joyce's short stories *Dubliners*, and in his great novel *Ulysses*. The earliest drawings, dated 1904, are contemporary with the action of the novel. They provide a contemporary record of a world, which had many similarities to that of Leopold and Molly Bloom, a hundred miles down the road.

Discussion of Conor's drawings as a historical record is not meant to detract from their value as artistic creations. The artist Rowel Friers believed that Conor's pencil sketches showed his draughtsmanship better than any other aspect of his work.[23] However, the surviving sketches are also a historical source of the first order, a powerful connection with past reality. Seamus Heaney has pointed out that any object surviving from a previous time can achieve this:

> To an imaginative person, an inherited object…becomes a point of entry into a common emotional ground of memory and belonging. It can transmit the climate of a lost world and keep alive in us a domestic intimacy with realities that might otherwise have vanished.[24]

If humble utilitarian objects can achieve this, we can expect an even greater impact from these fragments, which bear witness to their time, the people represented, and the affection and skill of the gentle man whose artistry created them.

Right: **Self portrait (c.1960)**

NOTES AND REFERENCES

1 Wilson, Judith, *Conor 1881–1968: The Life and Work of an Ulster Artist* (Belfast: Blackstaff Press, 1977)
 Hewitt, John, *Art in Ulster: 1* (Belfast: Blackstaff Press, 1971)
 Kennedy, Brian P., *Irish Painting* (Dublin: Town House, 1993)
2 Conor once commented that 'In a drawing of much detail…I prefer to use the pencil – whilst in a subject which requires broader treatment, I find myself at home with the crayon' Wilson, op. cit., p.24
3 Hewitt, op. cit., p.88
4 Wilson, op. cit., p.65
5 Ibid, p.121
6 Personal comments by Terence P. Flanagan and Kenneth Jamison, February 2001
7 Ibid
8 Wilson, op. cit., p.65
9 Ibid, p.98
10 Ibid, p.113
11 Ibid, p.100
12 Ibid, p.87
13 Ibid, p.64
14 Ibid, p.105
15 BBC The Arts in Ulster Broadcast of NIHS, 18.05.61
16 BBC 19/140U676. Broadcast 17.05.1981
17 Ibid
18 Gribbon, Sybil, *Edwardian Belfast: A Social Profile* (Belfast: Appletree, 1982), pp.22-23
19 Kennedy, Brian op. cit., p.33
20 Jamison, Kenneth, 'Painting and Sculpture' in *Causeway: The Arts in Ulster* ed. M. Longley (Belfast: Arts Council of Northern Ireland,1971),p.44
21 Jamison, Kenneth. Personal comment, February 2001
22 Hewitt, John, *The Collected Poems of John Hewitt* ed. F. Ormsby (Belfast: Blackstaff Press, 1991), p 225
23 'William Conor' BBC 19/140U676. Broadcast 17.05.1981
24 Heaney, Seamus, 'The Sense of the Past', *History Ireland*, Spring 1993 issue, p.33

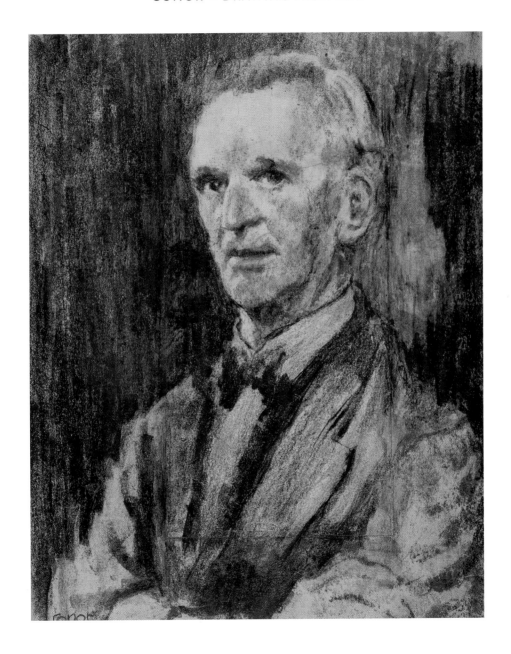

Belfast in the Early Twentieth Century

SOMEONE ONCE commented that Belfast has a beautiful setting, it was a pity they had to build Belfast. An English journalist, describing the city in the 1970s, summarised the picture many people would also have formed of the city's appearance in Conor's time:

> It's the houses that make the first impression…what strikes one so very hard when looking at Belfast, are the row upon row of grimy, uninteresting, sorry and forgotten rows of workers' houses…a city of so obviously poor, hardworking and intensely proud and loveable people, forced to live in damp, cramped, rotten, rat ridden, dirty and dying houses: houses they adorn with all the glitter and tribal gaiety possible, to stop the creeping doom of community despair.[1]

The poverty and grime were very much part of Conor's world, and the city's people also captured his affection and imagination. It would be wrong, however, to see Conor's Belfast as only a place of suffering and want. The period before the First World War, when Conor produced most of the drawings illustrated in this book, was a time when the city enjoyed greater industrial and commercial wealth than any time before or since.

In the second half of the nineteenth century, Belfast had grown faster than any other city in Britain or Ireland, from around 90,000 in 1850, to 349,000 in 1901.[2] The increase in population was largely due to migration of people from the countryside. Only one fifth of the

Right: **Queen's Bridge, Belfast (c.1920)**

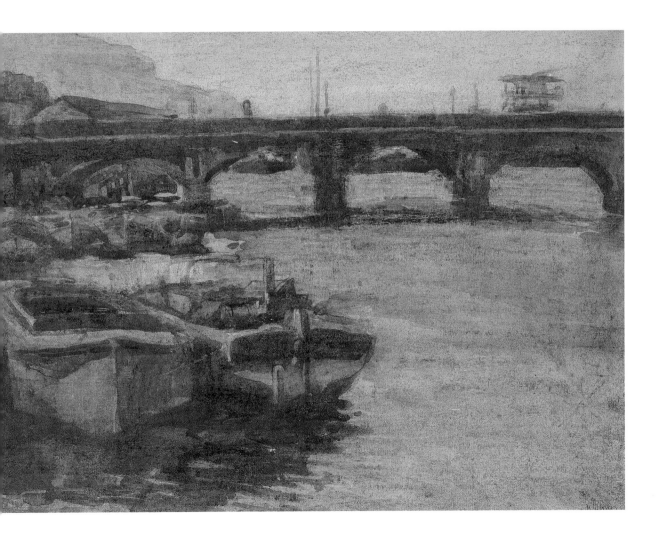

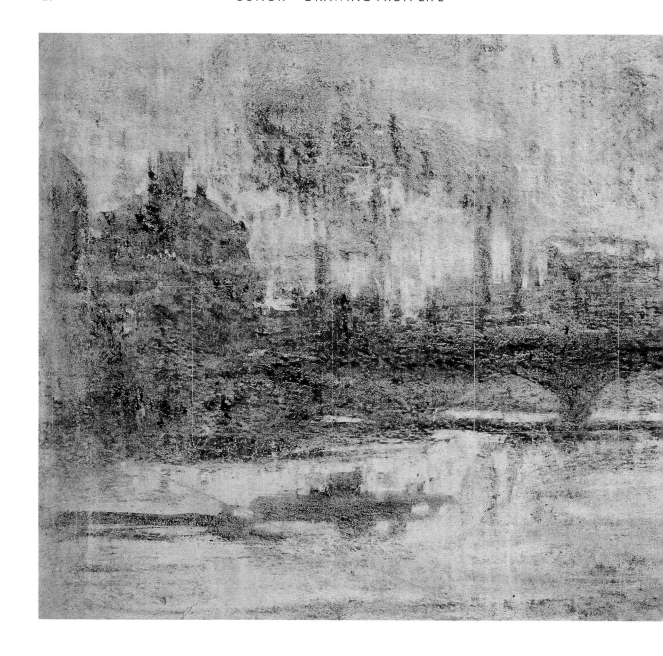

householders had been born in the city. Major industries such as shipbuilding, engineering and textiles were well established. By 1900, Belfast had become the largest port in Ireland and led the world as a centre of shipbuilding, especially in the production of big ships for the navy and the merchant marine. The Belfast Ropeworks Company was the largest in the world. The city had a remarkably high number of skilled workers. In 1900, more than a quarter of the male workers were skilled artisans. Between 1870 and 1914 Belfast was the largest linen producing centre in the world, with around 30,000 people employed in the industry, 23,000 of these being women.[3] Printing, bookbinding, and Connor's own trade of lithography, employed about 1,400 men.[4]

It is against this background that the life of the city shown in Conor's work has to be understood. By 1900, the picture of densely packed industrial housing overshadowed by mill chimneys was characteristic of west Belfast. Attempts were made to improve housing in working class areas, but appalling conditions were still common. After 1878, all new houses

Left: **Queen's Bridge, Belfast (1920)**

had to have rear access, but in 1898 only 20,000 out of the 70,000 houses in Belfast had this, and all rubbish, including the contents of ashpit privies, had to be carried through the living quarters to the street for collection. By 1900, more than 50,000 homes in the city had water closets, but almost 30,000 still has older ash privies. A House Cleansing department was responsible for the collection of refuse. In 1900, over 137,000 tons of refuse was collected of which about 34,000 tons were sent out to the country and disposed of to farmers. Working class housing conditions deteriorated in the period before the First World War, when very few workers' homes were built. As late as 1911, a Local Act showed how bad things could be.

> The following provisions shall apply to any shop or other part of a building…[where food] is sold or exposed for sale.
> a. No urinal water-closet or earth-closet privy ash-pit…shall be within such room shop or other part of a building…
> d. No such room shop or other part of a building shall be used as a sleeping place…to prevent risk of infection…
> 81. No cart which contains or has contained manure…shall be used for the conveyance of any…vessel containing…milk buttermilk or butter.[5]

The grind of working class life can be contrasted to the middle class world of the city's rapidly expanding suburbs. Most of the 11,000 houses built in Belfast between 1900 and 1917 were for middle class people.[6] After 1896, the new residential areas were served by the Belfast Street Tramways Company, established in the 1870s and taken over by the Corporation in 1904. By 1900, the leafy suburbs of south Belfast had become desirable for reasons of health as much as status. Professionals such as doctors, solicitors and architects moved to the Malone Road and the University area, and also to the Antrim Road, Ballynafeigh and Knock. These households employed around 6,500 women in domestic service.[7] Lord Shaftesbury's household, with nineteen servants, was at the apex of local society, but wealthy commercial families also had an enviable life style. Family members of Conor's employers, David Allen and Sons, for example, were accustomed to go sailing on Belfast Lough on Sundays, after church, the boat loaded with picnic baskets, stout, and whiskey.[8]

Commercial Life and Services

Retailing in Belfast had expanded greatly during the late nineteenth century and along with this the range of goods for sale. By 1900, the city had five major department stores; Arnott's, Robbs, the Bank Buildings, Anderson and McAuley, and Robinson and Cleaver. There were four branches of Liptons and six of the Home and Colonial Stores. Belfast Co-operative Society had eight branches throughout the city, its massive central premises being completed just before 1914. The first two decades of the twentieth century saw a massive expansion of consumer goods. Condensed milk, sewing machines, cigarettes and viyella were all available. The middle class, and to some extent the working class, had begun to eat tinned meat, gelatine, lump sugar, and factory-made biscuits and jam. Global trade had to some extent displaced local produce. Belfast people were eating New Zealand lamb chops, American Cheddar cheese, Danish butter, and Italian ice cream.[9] The power of advertising and its potentially intrusive nature were becoming recognised. In 1900, a by-law was passed aimed at regulating the use of hoardings for advertising.[10]

Specialist shops which were found in over 80% of even small Ulster towns by 1900, included hardware shops, grocers, pubs, drapers, post offices, tailors, blacksmiths, boot/shoemakers, butchers, and chemists. Other services found in towns of all sizes included markets, courts, banks, and dispensaries. Professions such as doctors, policemen, bankers and teachers were almost ubiquitous. By 1900, Gas companies had appeared as a significant new public service.

Health

There is almost always a close link between disease and poverty. In Ulster in 1900, there were over 9000 people in workhouses and 13,000 receiving public relief. Belfast's Board of Guardians granted the lowest amount of outdoor relief anywhere in Britain or Ireland, but things began slowly to improve. By 1909, for example, limited old age pensions had been introduced for some people over seventy years of age.[11]

In 1900, Belfast was claimed to be one of the worst cities in the UK for typhoid, and whooping cough, measles and scarlet fever. In

1900, there were 1,777 cases of typhoid in the city, and in 1906 it was alleged that no other city in the United kingdom equalled or even approached Belfast for the scale of endemic typhoid.[12] TB was a major scourge. In 1900, the recognition of the highly infectious nature of the disease led to a circular being sent to all workhouse Boards, stating that separate wards were to be set up for TB sufferers. Occupational diseases remained a major problem. Lung diseases were particularly common in the linen mills, particularly in the flax preparing departments of mills, where the clouds of fibrous dust could lead to a deadly form of TB, which often manifested itself in a condition known as 'spoucey'. In the early 1890s, nearly half the linen workers who died in Belfast were suffering from this condition, and 90% of these died before they were 40 years old. Bronchitis and similar illnesses were particularly common amongst workers in weaving factories, because of the high humidity required in the working areas.

Particular health concerns in 1900 centred on outbreaks of the Bubonic Plague and smallpox in Glasgow. Six cases of smallpox were recorded in Glenties, County Donegal, introduced by people returning from Glasgow. It was suggested that a ban should be put on the importation of rags and old clothes from Glasgow, and that anyone arriving from the city by boat, should be medically inspected before disembarking. However, it was decided that vaccination was the best measure. In 1900, over 31,000 people in Ulster received some sort of vaccination. By 1900, the need to clear refuse, prevent overcrowding in living quarters, and avoiding pollution of the water supply, were all recognised as essential preventative measures to prevent the spread of plague.

Social and Cultural Life

Between 1900 and the outbreak of the First World war, social movements, which made significant impacts on urban life included the co-operative movement, and the temperance movement. Friendly Societies of all sorts were flourishing, as were trade unions, and religious and political organisations. Sectarianism had become entrenched in Belfast during the late nineteenth century. Most people coming to live in the city from rural areas were Protestant. The

Right:. **Docklands, Belfast (c.1950)**

proportion of the population who were Catholic fell in the late nineteenth century, so that by 1900, they made up only a quarter of the population. Many Catholic men leaving rural areas preferred to emigrate than to face the sectarianism and discrimination in employment which had become widespread in Belfast. Catholics lived in the poorest housing and were much more likely to be unemployed, or working as unskilled labourers than Protestants. Catholic women did a little better than Catholic men, finding work mainly in the linen mills, or as domestic servants.[14]

In the first decade of the century, however, its notorious sectarianism did not prevent Belfast's cultural leaders from participating in the upsurge of cultural activity which became known as the Celtic Revival. After a visit to Dublin's Abbey theatre, the revolutionary republican Bulmer Hobson declared, 'Damn Yeats, we'll write our own plays!'[15] Between 1900 and 1910, there was a period of respite in political tensions, probably related to a Conservative victory in Westminster, which meant that Protestant Unionist fears of Home Rule temporarily subsided, and political issues arising from the national question were

relatively dormant. The Gaelic League and the Gaelic Athletic Association were successfully organising revivalist cultural activities that would become explicitly associated with nationalism, but up until about 1910, it was still possible for people who were not politically Nationalist, to participate comfortably in many of these events and movements. For a period also, class interests united workers, especially in the early stages of the Carters' and Dockers' strike of 1907, and a strong labour movement seemed briefly possible. Conversely, however, the period was one of triumphalist colonialism. The British Empire was at its height, with imperialist sentiment focussed on the Boer War, which had begun in 1899.

Cultural life in towns and cities had a well developed infrastructure by 1900. This was very evident in Belfast. The Belfast Free Public Library, Art Gallery and Museum opened in 1890, and acquired paintings and sculpture under the guidance of a curator. In the 1890s, music halls and theatres included the Alhambra, the Olympia Palace, and the Empire Theatre of Varieties. The Grand Opera House was opened in 1895, and in 1900 variety and theatre dominated commercial entertainment. The first

films were shown in the Alhambra and Empire in 1896. Tea/coffee rooms had become common in towns, often run by temperance organisations.

In sport, middle class people were taking up golf, cricket, tennis and cycling, while soccer had become highly organised. The Irish Football Association was established in Belfast in 1880, and the first international, against England, was played in 1882. (England won 13-0!). The first attempt to play football by electric light was organised, with limited success, in 1891, and professionalism was accepted by the IFA in 1894. By 1900, also, Gaelic sports as organised by the Gaelic Athletic Society, were beginning to be played in Ulster towns.

If the notion of Belfast as a grim, hard industrial city had become fixed by 1900, there was also a huge variety of human experience which an artist like Conor could record. Many aspects of life outlined above, appear in his drawings.

NOTES AND REFERENCES

1 Winchester, Simon, quoted in Singleton, D. A., 'Belfast: Housing Policy and Trends' in *Province, City and People* eds. R. H. Buchanan and B. M. Walker (Antrim: Greystone Books, 1987), p.151
2 Collins, Brenda, 'The Edwardian City' in *Belfast: The Making of a City 1800–1914* (Belfast: Appletree, 1983)
3 Ibid, p.178
4 Ibid, p.177
5 *Belfast Local Acts 1845–1936* pp.990–992
6 Bardon, Jonathan, *Belfast: An Illustrated History* (Belfast: Blackstaff Press, 1988), p.164
7 Collins, Brenda op. cit., p.169
8 Ibid, p.180
9 Ibid, p.181
10 MacManus, Megan, 'The Functions of Small Ulster Settlements', *Ulster Folklife* vol.39 (Holywood, 1993)
11 Collins, Brenda op.cit., p.175
12 Ibid, p.181
13 Ibid
14 Ibid, pp.173,175
15 Bardon, Jonathan op.cit., p.168

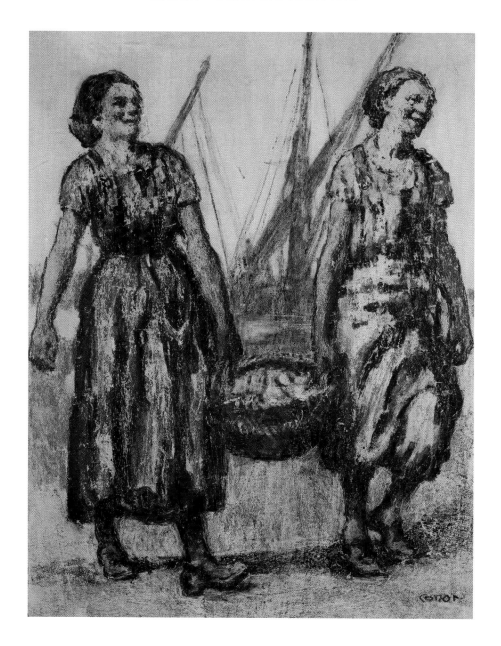

Working Life

Conor's paintings famously celebrate shipyard men and women mill workers. In the countryside, he also made accurate drawings and paintings of ploughmen, fishermen and women harvesters. Some of his most carefully observed drawings, however, show men working at desks. These seem to have been the happy outcome of hours of office boredom during the time he worked in David Allen & Sons.

Left: **Fisher girls at Ardglass (1945)**

Women around Ardglass often bought baskets of herring to sell locally. However, many of the girls who came to work at herring gutting in Ardglass were from Donegal. Hundreds of women travelled each year to Ardglass and curing stations in Britain, moving as the season progressed between ports as far apart as Lerwick and Great Yarmouth. The hard work and long hours were notorious, and women said that it was the crack in the evenings which kept them going. In 1913, Colm ÓLochlainn collected one of the most famous of all Donegal songs, *Mary from Dunloe,* from a fisherman at Ardglass, W. Feenan. He had learnt if from a Donegal girl.[1]

1 Ó Lochlainn, Colm, *The Complete Irish Street Ballads* (Pan: London, 1939 (1984)), p.226

Right: **Man working at desk, David Allen & Sons**

The history of Allen's firm is one of Victorian entrepreneurial activity, which changed a small family firm into a global business. David Allen set up his own business in Belfast as a master printer, in 1857. His first big contract was for printing the *Belfast Times* in 1872.[1] In 1873, however, the firm began to undertake lithography work, and within a quarter of a century a world-wide network of the Allen poster-printing business had been developed.[2] By 1888, the Belfast plant was being geared to lithographic printing, for which there was widening scope in the commercial and theatrical worlds.[3] In 1890, the firm opened an office and installed letterpress printing machinery in London, off Leicester Square,[4] by which time its main business was the production of play billings. By 1893 another office had been opened in Manchester to keep pace with provincial orders, and agencies had been set up in New York, Sydney, and Melbourne.[5] In 1894, a printing works was opened in Harrow.[6] By 1897, when the firm became a limited company, it was the largest pictorial placard printers in the UK.

Conor became apprenticed to David Allen and Sons in 1904, where he worked in poster design.[7] He was employed as the 'Black Man' in the Lithography Department of the Belfast offices. The artist Rowel Friers said that this was the job requiring the highest artistic skill.[8] The Black Man drew with a black crayon on a slab of limestone. He would copy from a sketch placed in front of him, reproducing each area of colour in black, filling in blocks which were then used for the separate printing of each colour.[9]

1 Allen, W.E.D., *David Allens: The History of a Family Firm 1857-1957* (London: Murray, 1957) p.90

2 Ibid, p.92

3 Ibid, p.104

4 Ibid, p.106

5 Ibid, p.108

6 Ibid, p.109

7 Wilson, Judith, *Conor 1881–1968: The Life and Work of an Ulster Artist* (Belfast: Blackstaff Press, 1977) p.4

8 Friers, Rowel BBC Radio Interview (BBC 19/14 OU676 Broadcast 17.05.1981)

9 Wison, Judith op. cit., p.4

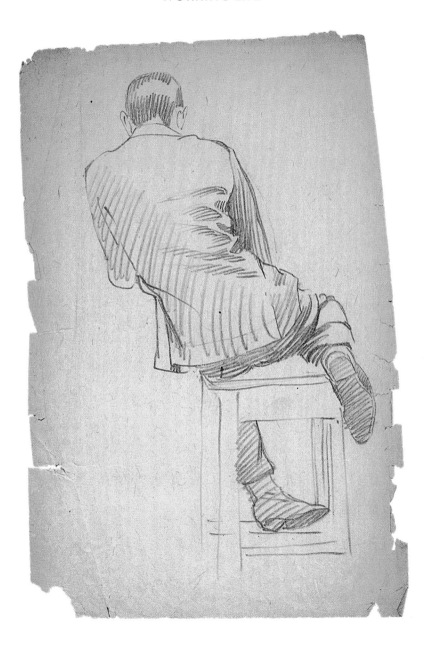

Right: **Man working at desk, David Allen & Sons**

The years from 1895 to 1914 were the Golden Age of the David Allen printing business.[1] This was also the hey day of the British theatrical poster. In 1908, Allens claimed to be the largest bill-posting firm in the world.[2]

By the end of the nineteenth century the influences of artists like Toulouse-Lautrec and Mucha had begun to influence poster design in Britain. It was claimed that David Allen & Sons did much to encouraged the movement and raised standards, by careful selection of the best talent.[3] However, the history of the firm written by a family member, W.E.D. Allen, makes no mention of Conor as an artist employed by the firm. This suggests that even by 1957, when the history was published, Conor's paintings were not known to the Allen family. However, his drawings of the young men with whom he worked in Allens, convey a peaceful ennui, familiar to many twentieth-century office workers. Conor left David Allen's around 1910.

1 Allen, op.cit.,p.113
2 Ibid, p.156
3 Ibid, p.115

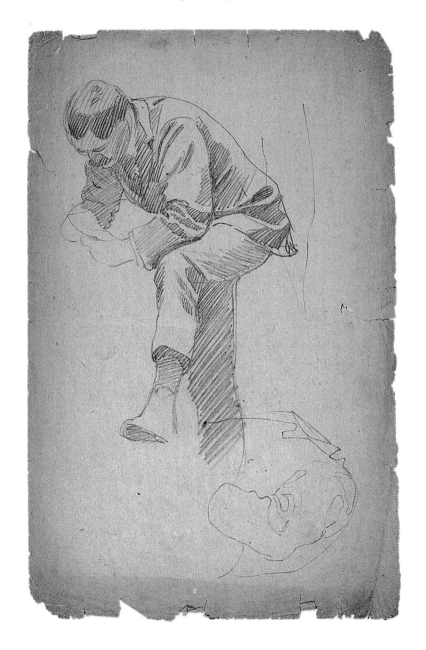

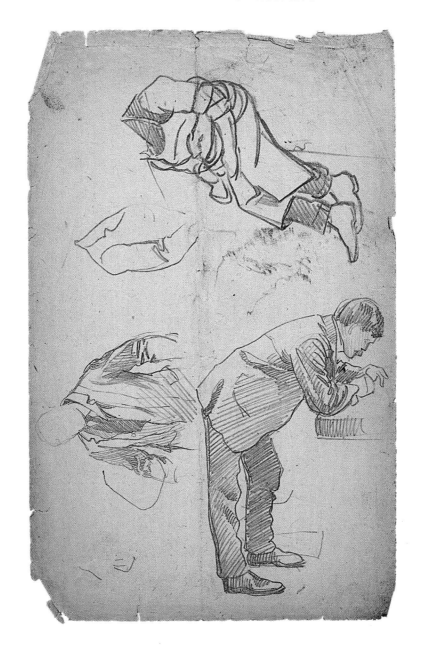

Left: **Men working, David Allen & Sons**

The growth of Allens' international business was accompanied by a move in the family's main residences, first to Killiney outside Dublin, and then to the south of England. Some of the family kept close ties with Belfast, but others did not display much affection for it. Samuel Carson Allen, for example, who was born in 1869, and educated at R.B.A.I., came back to Belfast on a visit in 1910 and commented, 'Belfast…looks more Belfasty than ever. What an unattractive place it is!'.[1] W.E.D. Allen commented that 'Sam left Belfast…because he loathed the place and hankered for the bright lights'.[2] He died in England in 1937.

The Allens began to have major business problems after the First World War. William Allen got the help of Sir Edward Carson 'the great Ulster lawyer and statesman' in negotiating compensation for the Harrow works which were requisitioned by the Stationery office during the war.[3] Other problems were not linked to wartime upheaval, however. By the 1920s theatrical orders were declining in the face of the expansion of the cinema. The firm's Belfast plant in particular, had become antiquated. The plant went into a slow decline and the Corporation Street premises were sold in 1942.[4]

1 Allen, op.cit., p.195
2 Ibid, p.202
3 Ibid, p.205
4 Ibid, p.142

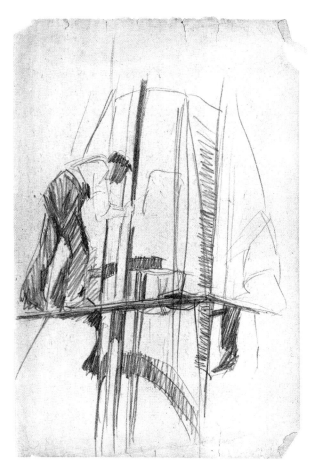

Left: **Workmen on wooden scaffolding**

Right, above: **Men working**

Right, below: **Roadworks**

Between 1850and 1900, Belfast was the fastest growing city in Ireland. By the early years of the twentieth century, however, the rate of construction works, which had absorbed the ongoing influx of rural male labourers, had slowed greatly. Even when work was plentiful, there was little job security. A cold spell, or a strike by unions representing skilled artisans, might leave unskilled workers jobless, and destitute.[1]

1 Gribbon, Sybil, *Edwardian Belfast: A Social Profile* (Belfast: Appletree Press, 1982) p.17

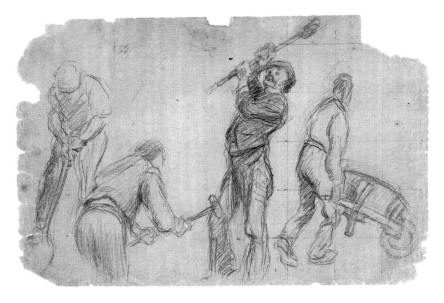

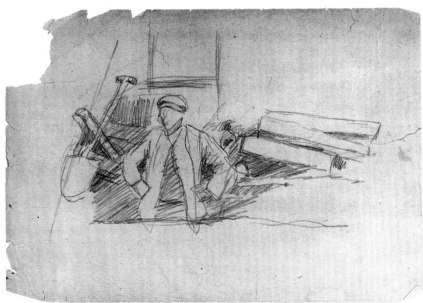

Right: **Ploughing (1910)**

This illustration conveys a lot of information, with
great economy. The shape of the plough beam shows
it to be an American plough of a type which became
fairly common in Ireland during the early twentieth
century. The mouldboards of these ploughs broke up
the furrow slice as it was turned over, which made
the tasks of harrowing and the mechanised planting
of seed much easier. The horses shown are of the
type known locally as 'clean boned'. This refers to
their feet, which were much smaller, and less hairy
than those of the larger working horses such as
Clydesdales. They were the type of horse used in
developing the famous Irish Draft breed. Many Irish
farmers preferred 'clean boned' horses, not only for
their neatness for walking in plough furrows, but
because they could also be used for pulling carts and
traps, and for riding.

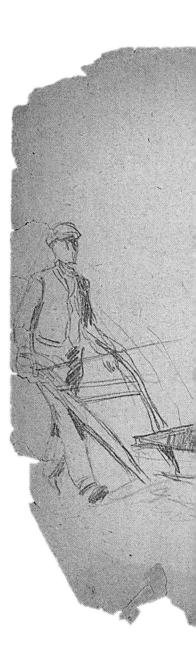

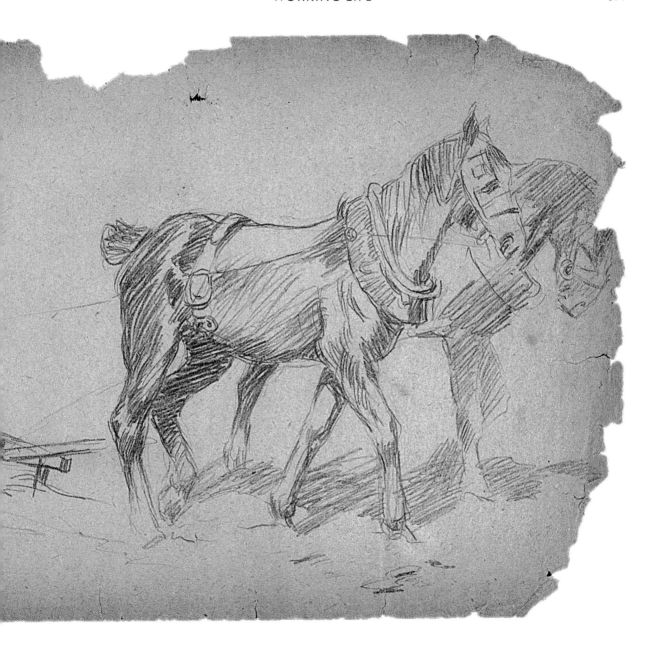

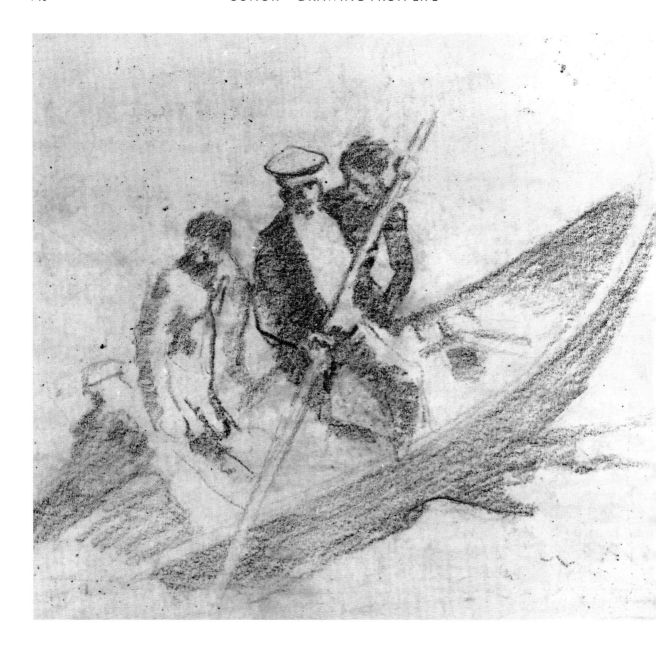

Left: **A currach**

Conor visited both Donegal and the Great Blasket
Island between 1908 and 1910. At this time many of
the coastal areas, and the larger islands off the west
coast of Ireland were populated by Gaelic speaking
people, who appeared culturally very distinctive,
compared to their more prosaic, and often urbanised
compatriots in the east of the country. The use of
currachs was one of the distinctive aspects of
everyday life on the western seaboard. The boats
were locally made from tarred canvas, stretched over
a light wooden frame of hazel and laths. They were
extremely buoyant, but also fragile. One of the most
famous Gaelic songs, *Anach Cuain*, describes the tragic
drowning of people in a currach in county Galway,
after a sheep being transported in the boat put its
foot through the canvas hull.

Right: **Gathering potatoes, near Portadown (c.1939)**

The clothes suggest that this painting dates from the 1930s. Before mechanisation, this was one of the hardest tasks on the farm. The Navvy Poet, Patrick MacGill, described Donegal 'tattie hokers' working in a Scottish potato field in 1904.

> All day long, on their hands and knees, they dragged through the slush and rubble of the field. The baskets which they hauled after them were cased in clay to the depth of several inches, and sometimes when emptied of potatoes a basket weighed over two stone. The strain on the women's arms must have been terrible.[1]

1 Macgill, Patrick, *Children of the Dead End* (Jenkins: London, 1914), p.77

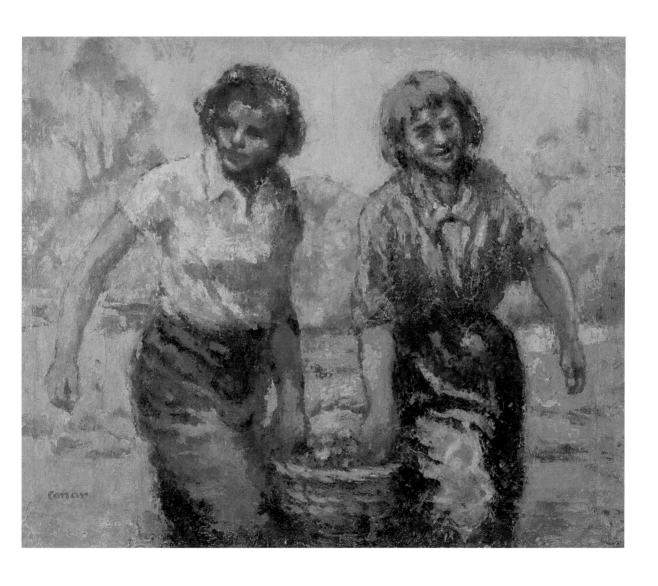

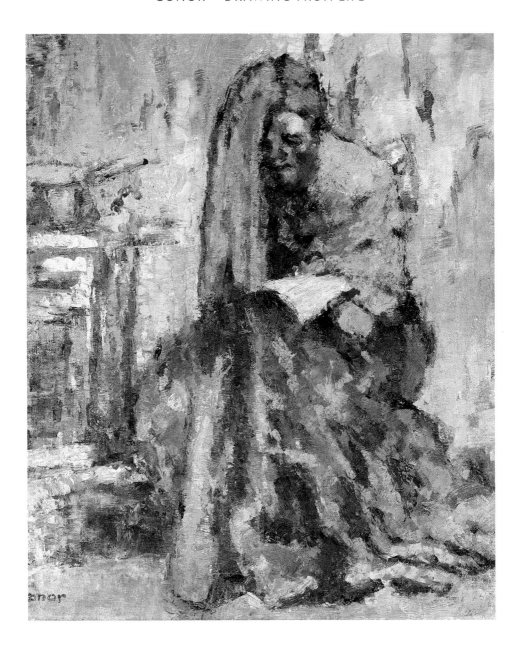

Home Life

Conor's family were the subject of some of his most accomplished and intimate drawings. These show a respectable, shabby, gentle world of washing, scrubbing, sewing, reading, and sleeping.

Left: **Girl drying her hair (c.1912)**

This painting is clearly based on the drawing on p.58. Conor had squared the drawing off, an indication that he intended to use it as the basis for a painting.

Left: **John with toothache (1907)**

William Conor was fourth in a Presbyterian family of seven children. For most of his life he lived with members of his family. Some of the most detailed and intimate of his drawings were obviously done at home. John was William's next youngest brother.

Left: **Man sleeping**

Right: **Man reading – smoking a pipe**

Briar pipes became popular after 1850, and by 1900 they had largely replaced the earlier clay pipes. Reading and smoking a pipe were often associated with tranquility and security. In 1924, Alfred Dunhill published a poem, which made this explicit.

> Give a man a pipe he can smoke,
> Give a man a book he can read,
> And his house is bright with calm delight,
> Though the room be poor indeed.[1]

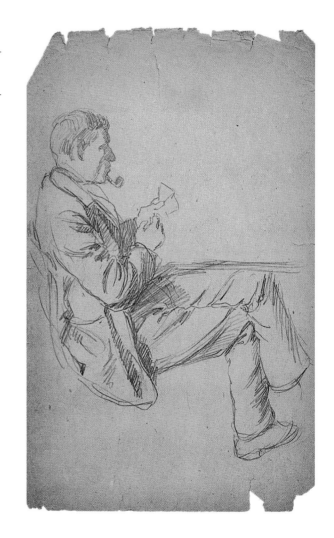

1 Dunhill, Alfred, *The Pipe Book* (London: Booker, 1969) Foreword to 1924 ed.

Right: **Man washing hands**

A lot of houses in early twentieth-century Belfast did not have plumbing. The eccentric antiquarian, Francis Joseph Bigger, produced plans for workers' housing in 1907, which deliberately omitted sinks from the facilities. Bigger commented that in his model cottage, 'Washing up is usually done in a bucket or basin on a large stool or low table, and the contents thrown out as soon as the work is done. This is clearly, and never so unwholesome as a sink'.[1]

1 Bigger, Francis Joseph, *Labourers' Cottages for Ireland* (Dublin: Independent Newspapers,1907), p.5

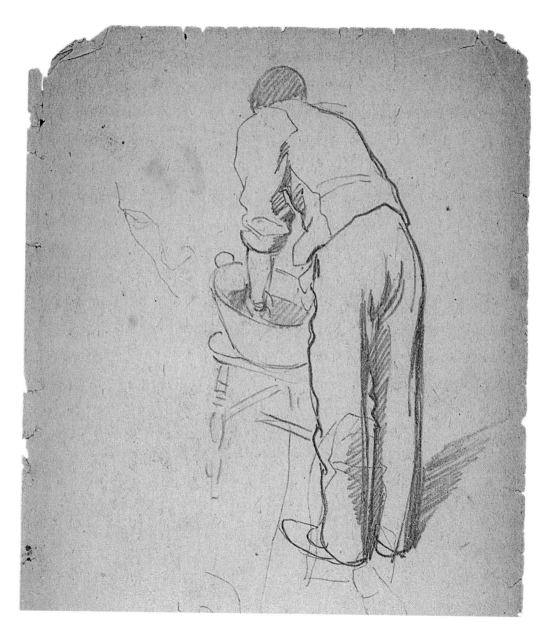

Below: **Woman sewing**

This drawing shows very clearly the difficulty of undertaking delicate tasks such as sewing, in Belfast houses during the early twentieth century. Natural light was restricted by window size, curtains, and in the back rooms of many houses, the proximity of a back yard wall. Most people in Conor's drawings would have had gas light in their homes by the first years of the century, but even this advance provided a very localised light source.

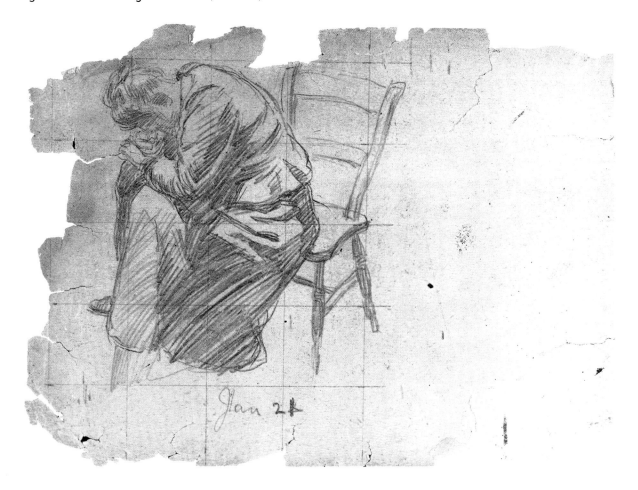

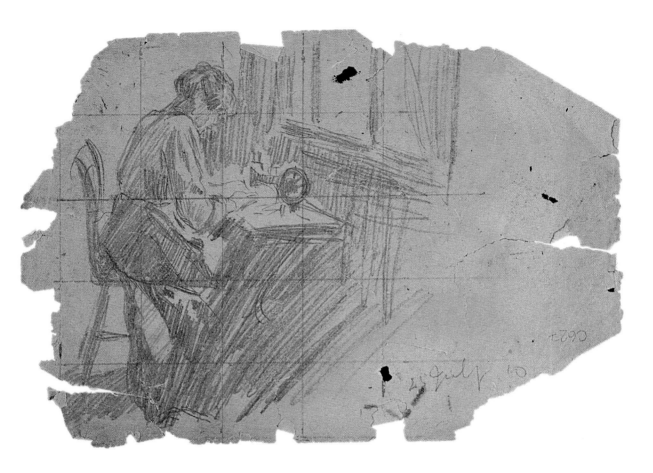

Above: **Woman at sewing machine (1910)**

The treadle sewing machine illustrated was probably a Singer 'New Home'. These machines became very popular in the early twentieth century, when the availability of hire purchase arrangements brought them within reach of the ordinary household. The machines were commonly used for dressmaking, and recycling of fabric into items such as patchwork quilts.

Below: **Couple conversing**

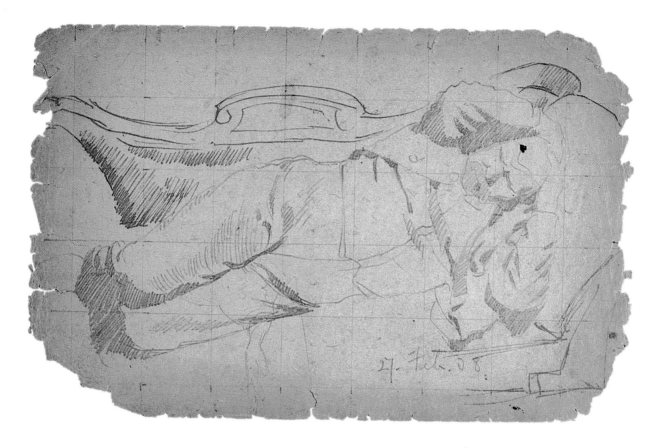

Above: **Man sleeping on sofa (1908)**

The sofa illustrated here has a long upholstered seat, with an inclined head rest at the end. By the middle of the nineteenth century, sofas like this were standard items of living room and parlour furniture in many middle-class and working-class homes. Single and double-ended couches were derived from the earlier and grander daybeds and *chaises longues* found in wealthy households. Later Victorian variants of the style were heavy, solid and comfortable. As here, sofas were often decorated with a large curved mahogany back rail, which might include carving, often in the then popular 'Grecian' style.

Right: **Woman Washing her Hair**

Between 1900 and 1914, women aimed to have hairstyles which had a look of soft fullness. Thick, wavy hair was seen as most desirable, and the piled up masses into which it was shaped meant that most women kept their hair long. People washed their hair much less frequently then than now. Hair was kept clean and shining by regular brushing and combing.

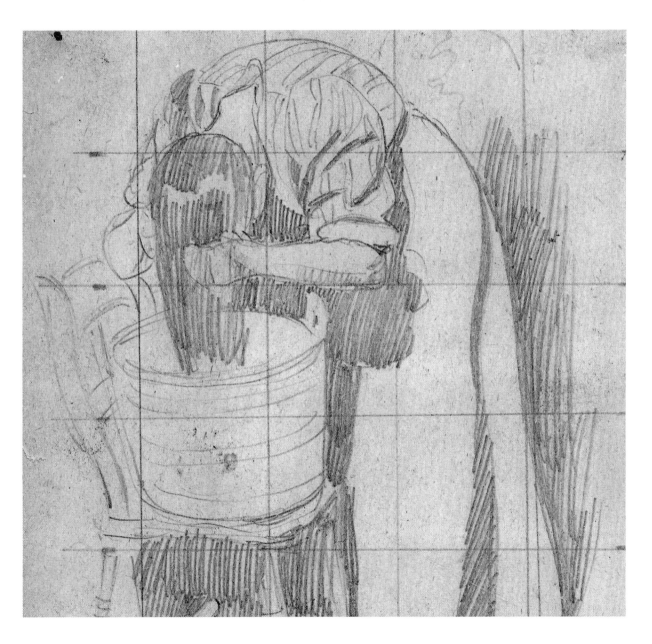

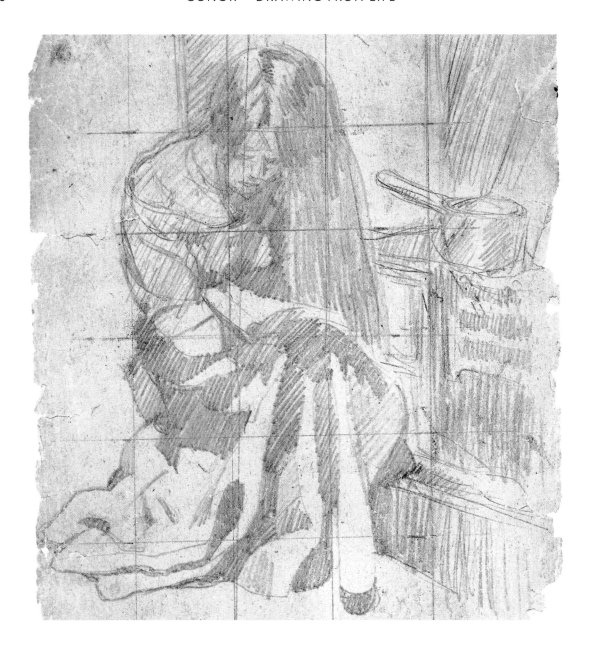

Left: **Woman drying her hair (1910)**

Drying long hair in front of a kitchen range was a lengthy task. However, very fashionable women went to great lengths to attempt to achieve a full, wavy look. A permanent waving process was invented by a German living in New York, in 1904, but this was an expensive and time consuming process. Less wealthy women who wished to be in fashion, more often relied on the use of curling tongs.

Right: **Woman scrubbing the floor**

Washing floors was a regular cleaning chore. From the 1880s the work was made easier because of the availability of carbolic soap, which had disinfectant properties. However, the lack of hot running water meant that water for washing had to be heated over the kitchen fire or range.

Up to the middle of the twentieth century it was also usual for 'house-proud' women to sweep and clean the front door step daily. The step was often brightened or coloured with a soft rubbing stone, and in many small terrace street houses, it was the custom to scrub a half-moon area in front of the doorway.

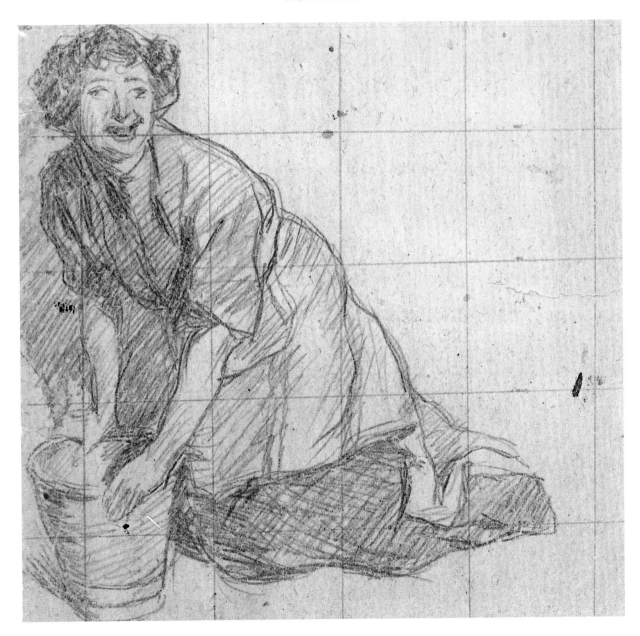

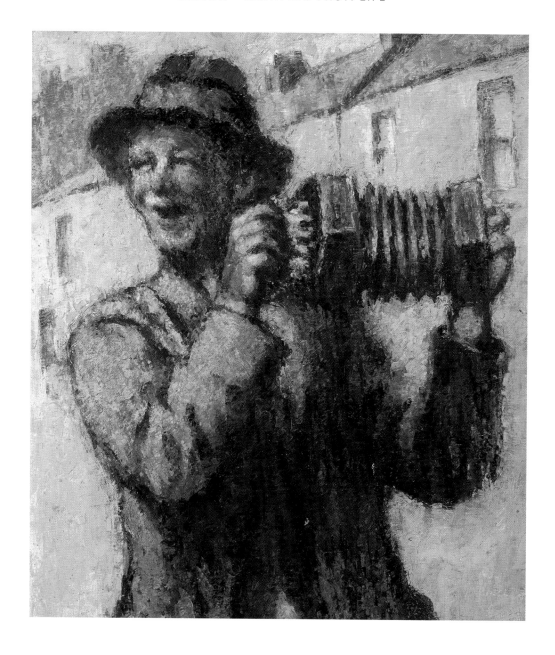

Music and Recreation

Conor could not play a musical instrument, but his drawings of pianists, traditional musicians, and concert performers, suggest that he delighted in listening to it. Other pleasures recorded included browsing in a library, buying chips, sitting on the beach at Portrush, drinking a quiet pint, or more grandly, playing polo.

Above: **Man playing concertina (1930)**

Oral testimony suggests that the man in this painting was from the Markets area of Belfast, where his sister had a second-hand clothes shop. Apart from his musical ability, he was said to be a fluent Irish speaker.

Right: **Young man playing the piano**

During the period he worked in David Allen and Sons, Conor socialised with a group of friends, with whom he went on trips in a motor bike and side car, to the countryside around Belfast. One house visited belonged to the aunt of Conor's friend Stanley Wilson. The aunt, Laetitia, lived in Bridge House, Doagh, and the group of six young men would go there to be fed, and to play the piano.

[Family and friends] retired to the drawing room and the old piano there. Almost everyone could both play and sing. Only Mary had to sit idly by and admire with shining eyes, with Willie Conor…who was worse-off than Mary, being tone-deaf. He, too, was desperately ambitious to be musical, and with the help of his friends and family did learn by rote, one tune on the keyboard – 'The West's Awake'…He never learnt another tune, but sat back happily sketching his friends round the piano, where immortalised by him, they remained for ever.[1]

1 Wilson, Judith op.cit., pp.5-6

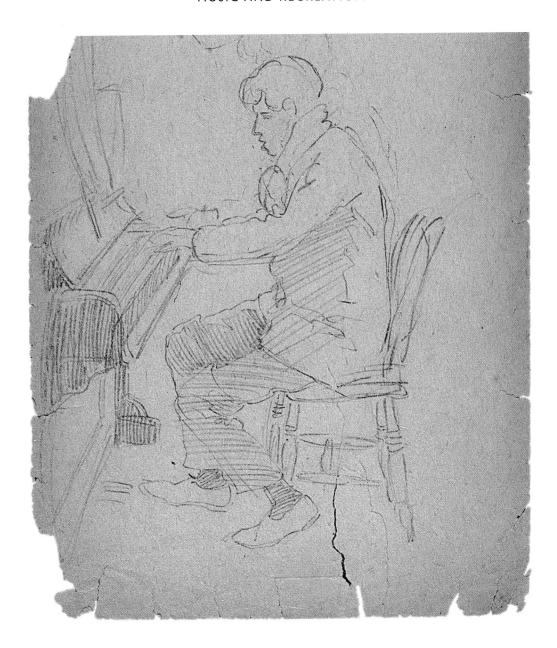

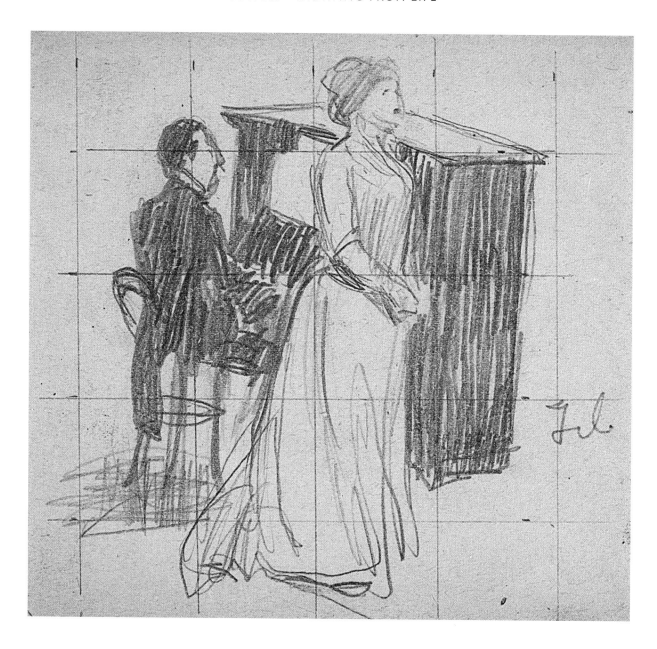

Left: **Woman singing, accompanied by man on piano (1910)**

Concert recitals were very popular in early twentieth century Belfast, the artists' repertoires including famous operatic arias, and the world famous parlour music of Irish song writers such as Thomas Moore, and Michael William Balfe.

One of Conor's friends at David Allen & Sons, Gerry Burns, played the violin at night in the Grand Opera House Belfast, and Conor was also interested in the theatre.[1] However, the most celebrated visit by a performing artist to Belfast in the first decade of the twentieth century was a fictional one. The week after the action described in *Ulysses*, in 1904, Molly Bloom was booked to sing in the Ulster Hall.

Mr Bloom turned his large lidded eyes with unhasty friendliness.

My wife too, he said. She's going to sing at a swagger affair in the Ulster Hall, Belfast, on the twentyfifth…It's a kind of a tour, don't you see?

Mr Bloom said thoughtfully. Part shares and part profits…

Mr Bloom, strolling towards Brunswick street, smiled…Thought that Belfast would fetch him. I hope that smallpox up there doesn't get worse. Suppose she wouldn't let herself be vaccinated again…

[and Molly, thinking of her lover, Blazes Boylan] he could buy me a nice present up in Belfast after what I gave they've lovely linen up there or one of those nice kimono things I must buy a mothball like I had before to keep in the drawer with them it would be exciting going around with him shopping buying those things in a new city better leave this ring behind want to keep turning and turning to get it over the knuckle there or they might bell it round the town in their papers or tell the police on me but they'd think were married.[2]

1 Wilson, Judith op.cit., p.8
2 Joyce, James, *Ulysses* (Harmondsworth: Penguin, 1922 (1968)), pp.76,77 670

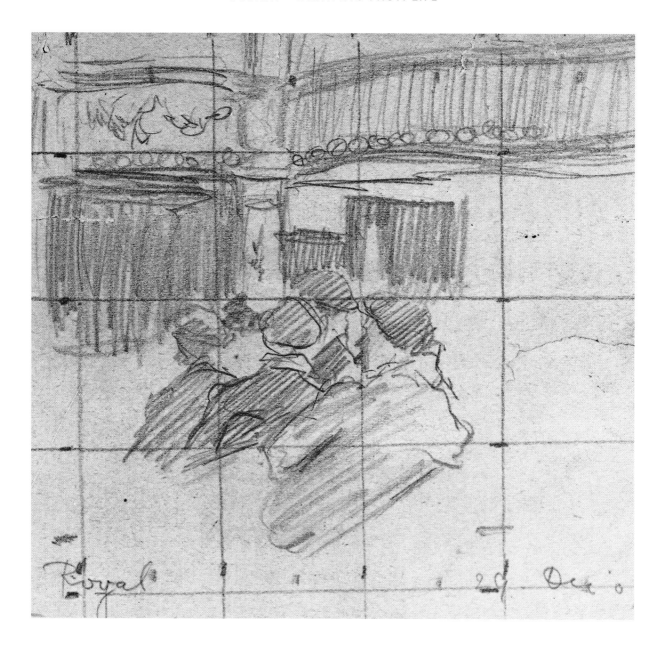

Left: **Theatre Royal. View from the Pit**

The first Theatre Royal was built in Arthur Street, Belfast in 1793. It was rebuilt in 1871, and refurbished after a fire in 1881. By the late nineteenth century, the easy movement of *artistes* from England meant that local talent featured much less in the theatre's performances. By the early twentieth century, variety and revived plays dominated the entertainments. The theatre was converted to a cinema in 1915, and the building was demolished in 1961.[1]

1 Patton, Marcus, *Central Belfast: A Historical Gazetteer* (Belfast: Ulster Architectural Heritage Society, 1993), p.19

Right: **Hand playing accordion**

The button accordion, or 'melodeon' shown here appeared in Ireland in the second half of the nineteenth century. Its adoption into Irish traditional music coincided with a decline in pipe playing, and the spread of set dancing. By around 1900, the instrument with ten buttons had become known as the 'melodeon'. The popularity of the instrument came from its cheapness and also the ease with which a very full clear sound could be produced which would fill a room.[1]

1 Valleley, Fintan (ed.), *The Companion to Irish Traditional Music* (Cork: University Press, 1999)), pp.2–3

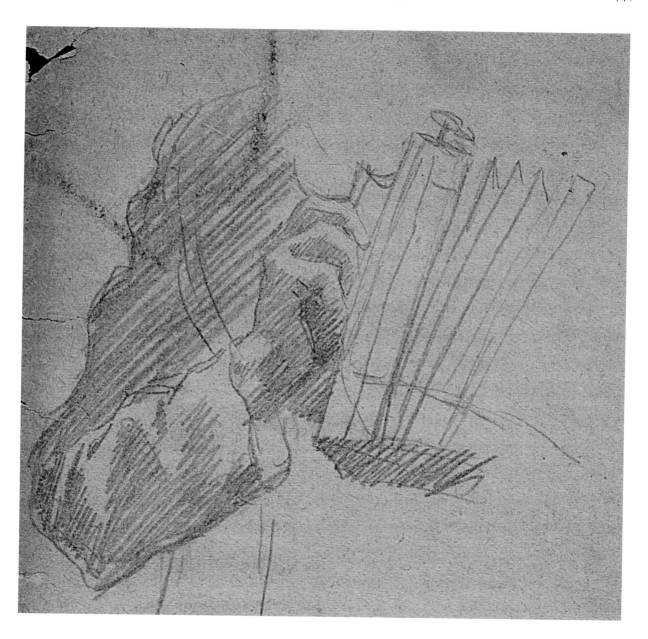

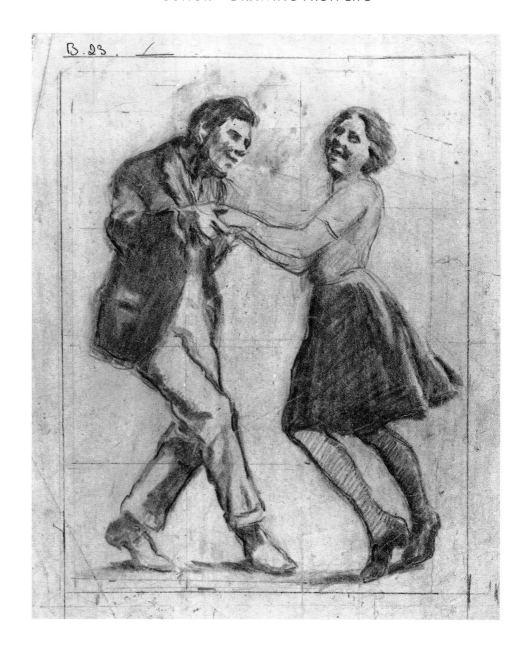

Left: **Dancing couple**

Conor made a number of versions of this drawing of a set dancing couple. The term 'set' dancing derives from a 'set of quadrilles', and represents a style derived from French dance movements, danced to Irish music. Set formations were known in Ireland by the late eighteenth century. By the early twentieth century, however, the dances were frowned on by both Christian clergy and the Gaelic League. The churches disapproved of the dances on moral grounds, and the Gaelic League because they showed too many outside influences, the early dances having been introduced to Ireland by British military personnel. In the face of this opposition and changing fashions, set dancing retreated to survive in a few areas of western Ireland, before having a nationwide, and international, revival in the 1970s.[1]

1 Valleley, Fintan (ed.) op.cit., pp. 346–347

Right: **Street organ player (1910)**

Street organs were developed in Europe around
1830, and they remained popular until about 1930.
Most were made in Germany, France or Italy.
Because of the need to keep street organs compact,
the number of pipes was kept limited. However, even
with the limited number of pipes, some had to be
fitted round corners in the organ, to make them fit in.
The music was produced by feeding a perforated roll
of paper, or pages of a cardboard book through the
machine. The organ music was regarded by many
contemporaries as an unattractive noise, but the
'celeste' tuning of the organs, where pipes were tuned
slightly different from each other, produced a flute-
like wavering sound, which many people found
evocative. T.S. Eliot described the sweet, resigned
melancholy of the music.

> I keep my countenance,
> I remain self possessed
> Except when a street piano, mechanical and
> tired
> Reiterates some common, worn-out song
> With the smell of hyacinths across a garden
> Recalling things that other people have desired.[1]

1 Eliot, T.S., 'Portrait of a Lady', *Collected Poems* (London:
 Faber and Faber, 1954 (1972)), p.20

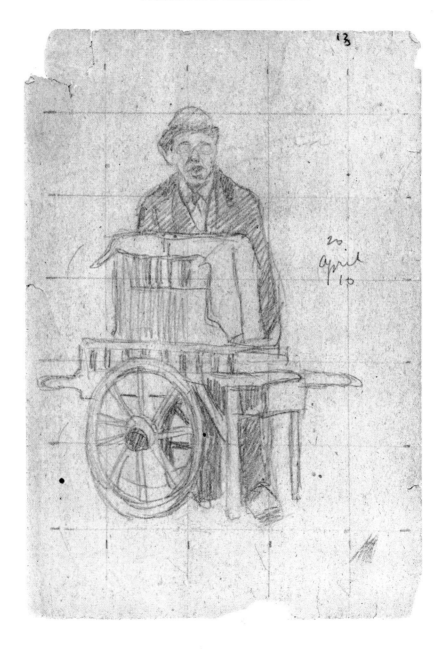

Right: **Reading Room, Belfast Central Library**

Belfast Central Library was built in Royal Avenue in 1881. Conor spent a lot of time there after he left David Allen and Sons in 1910. Once he had begun to work as a full time artist, he decided that he should study physiognomy. He commented, 'Physiognomy deals with the character of one's features. I started to study this very much'.[1] The library provided the texts which he required.

1 Wilson, Judith op. cit., p.8

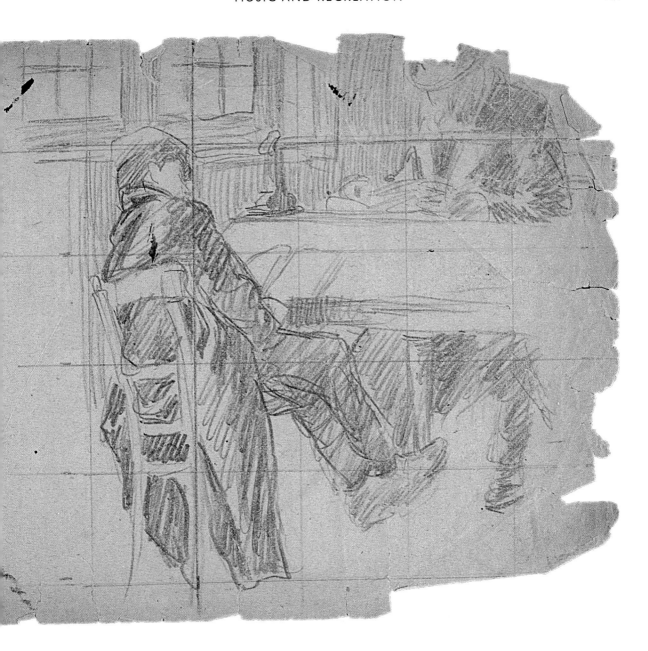

Right: **Looking into a pub (1909)**

Conor made several versions of this drawing. During the first half of the twentieth century, pubs were retreats for working-class and middle-class men. However, the drawing does not convey the scale of drinking in Belfast, or the disapproval of the respectable classes. One minister described Belfast as 'soaked in liquor' on Saturday nights. It was estimated that there was a licensed house, or an off-license, for every 328 inhabitants.[1] The drawing also cannot convey the powerful smells with which pubs were also associated.

> From the cellar grating floated up the flabby gush of porter. Through the open doorway the bar squirted out whiffs of ginger, teadust, biscuitmush [2]

1 Gribbon, Sybil op. cit., p.26
2 Joyce, James op. cit., p.60

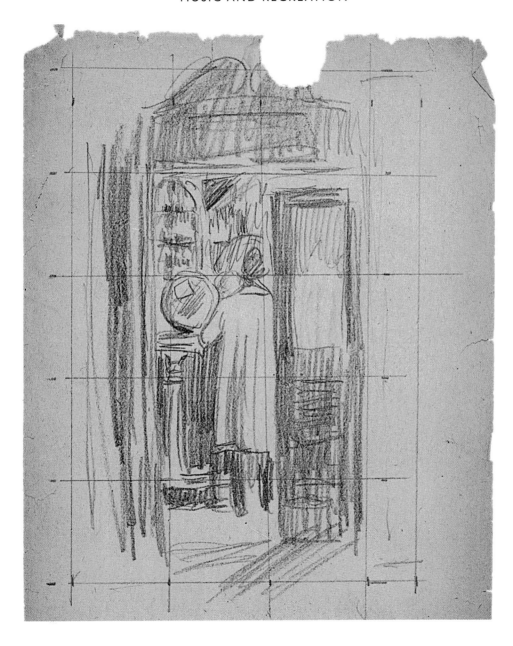

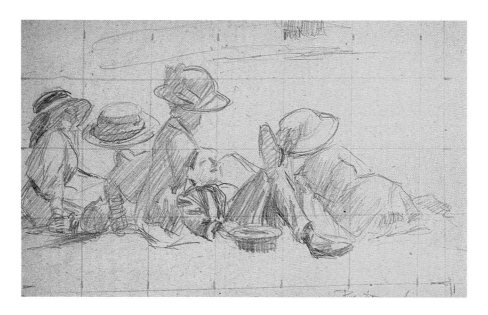

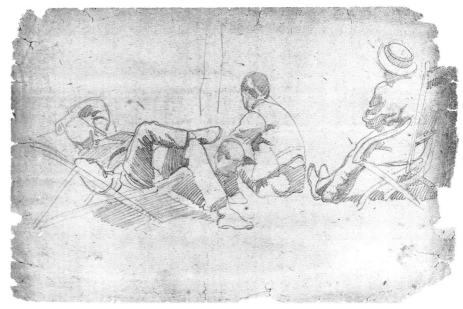

Left, above: **Group of women at Portrush (1910)**

Left, below: **Three men in deckchairs at Portrush**

Portrush was one of the seaside resorts which grew with the establishment of a rail link, creating the possibility of day trips and short breaks for masses of working people. By 1910, when the top drawing was made, regular steam services had been established during the summer months, linking the town to both Morecombe and Glasgow. Portrush had important tourist amenities, including baths, a golf course, tennis courts, twenty two hotels and a large number of guest houses. The confidence felt by contemporaries is evident from a directory entry for 1909.

Until recent years Portrush…about seven [miles] from the far famed Giant's Causeway, was but a small fishing village. Its popularity as a watering-place and the charm and attractiveness of its surrounding scenery has, however, of late brought it into great repute…splendid hotels… affording every comfort and accommodation to the weary invalid or those on pleasure bent…[The town's] salubrity, excellent sea bathing, and picturesque scenery has spread its fame as the Brighton of Ireland.[1]

1 *Belfast and Province of Ulster Directory* (Belfast: Publishing Office, 1909)

Right: **Polo player (1910)**

An ancient version of polo was played in Persia before 500B.C., but it probably came to Europe only in the nineteenth century, via Calcutta. The first English club was formed in 1871. Polo requires access to two or more ponies, as no pony is supposed to play more than two of the four, or six, periods known as *chukkas*, into which the game is divided. This has ensured that it is played mostly by wealthy people, and given its source in nineteenth century India, that it was particularly associated with colonial lifestyles.

A survey of the ponies of the British Isles was carried out just before the First World War. [1] The report concluded that the local Cushendall pony was the best polo pony in Britain and Ireland. However, the ponies shown in Conor's drawings appear to be much closer to thoroughbreds.

1 McBride, Jack, *Traveller in the Glens* (Belfast: Appletree Press, 1979), p.19

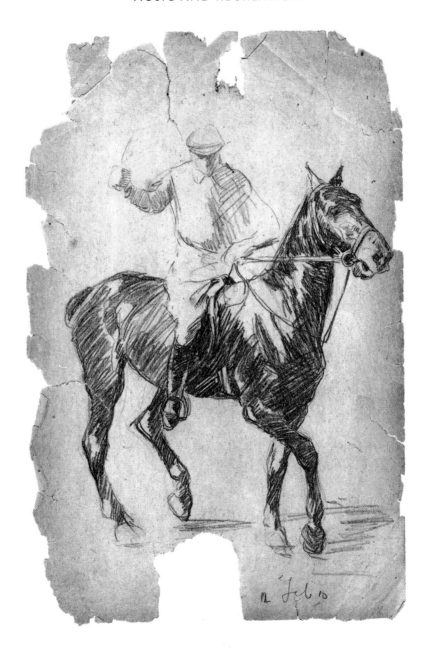

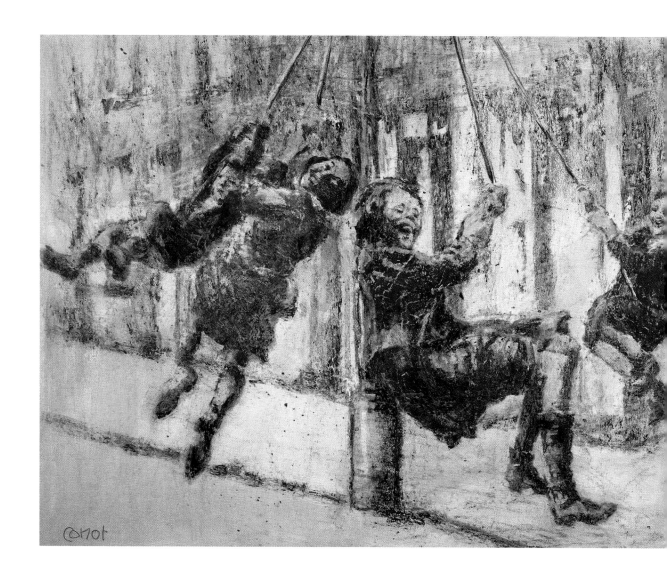

Street Life

Conor was proud of his sketches of the everyday life of local people, many of whom had no idea that their actions had been recorded. Everything he saw appears to have been worthy of the same loving attention; courting couples, playing children, cart horses, street vendors, and a pre-1914 novelty, the motor car.

Left: **Lamp post swinging (1957)**

This was one of the most popular childrens' street games. A pencil drawing of this scene by Conor in the Ulster Folk and Transport Museum archive shows a mirror image of the drawing, squared off to make it more easily copied as this more careful version.

Right: **Polling station School, 15 January 1910**

This was the election which put the Irish home rule issue back at the centre of British politics. The election was triggered by a dispute over the budget between the House of Lords and the Commons. The result was that, while the Liberals remained in power, they did so only with the support of the Irish Parliamentary Party under John Redmond. In return for his support, Redmond was able to insist that a new Home Rule Bill should be put before Parliament. Balfour and the Conservatives made opposition to home rule the main plank of their platform before the election which came soon after, in December 1910. Ulster Unionists had already begun to organise to fight any home rule bill, as early as 1905. Events in 1910 led to the emergence of Edward Carson as their leader, and by 1911, he was addressing a mass rally in Belfast, threatening to set up a break-away Protestant government in Ulster.

One obvious aspect of Conor's drawing is that everyone shown is male, the election predating the winning of women's right to vote.

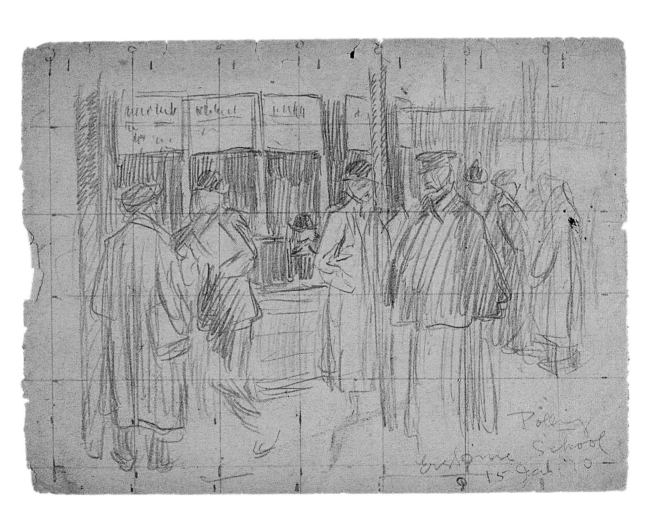

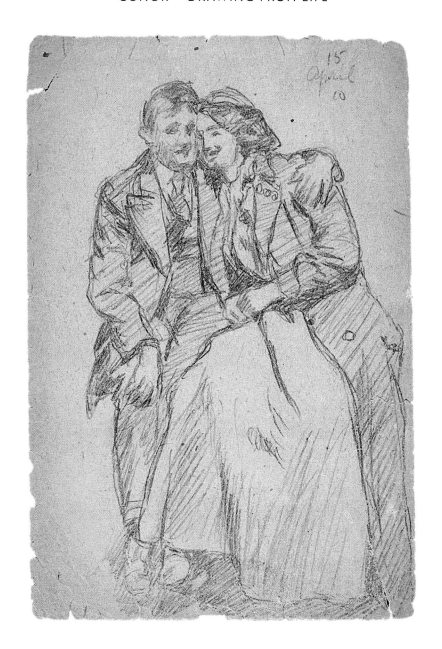

Left: **Loving couple (1910)**

This drawing fits well into the 'Darby and Joan'
genre. The original Darby and Joan were celebrated
in a ballad by Henry Woodfall, published in 1735. The
theme of old fashioned virtuous love was, however,
very popular throughout Europe. The French
equivalent is *C'est Roche et son Chien*. (In this case,
though, the inseparables were a man and his dog!)[1]

1 *Brewer's Dictionary of Phrase and Fable* (London: Cassell,
 1870 (1985)), pp. 312, 956

Right: **Car (1909)**

The car seems to be an 'Argyll', a make produced in
Belfast by Joseph Bell Ferguson, a brother of the
famous Harry Ferguson. J.B. Ferguson ran a large
garage and automobile business in Belfast at this
time, and would have supplied many of the cars in
use in the city. Most of the 3240 cars registered in
Ireland in 1909, were open-topped 'Tourers'. They had
no heaters, and as the drawing shows, this meant
that drivers and passengers had to wrap up well
before going out.

An 'Argyll' car, Reg. No. IW 66, belonging to W. S.
Johnston of Kiltonga, Newtownards, was used to
transport merchandise during the Belfast Carters'
Strike of 1907.

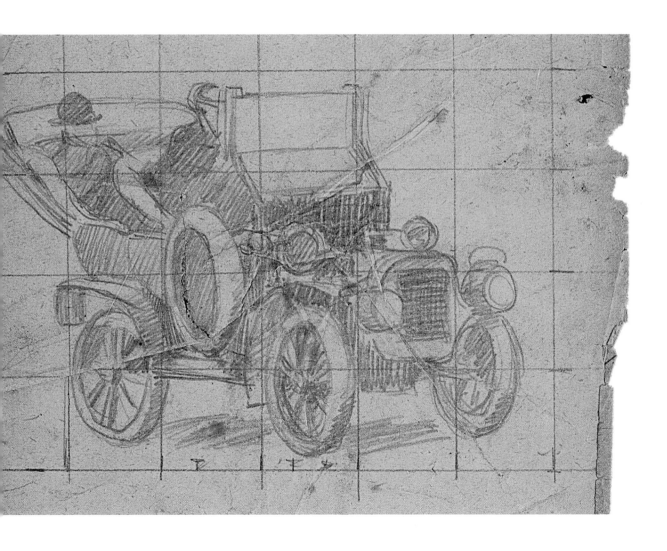

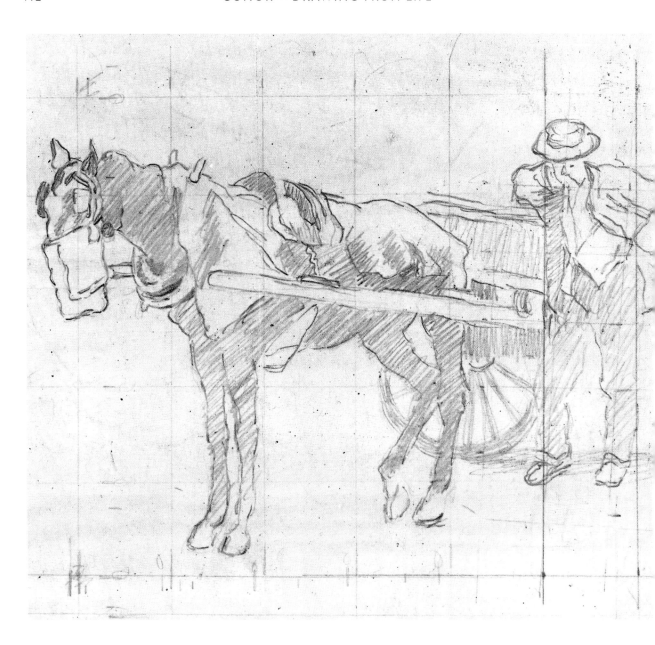

Left: **Horse and cart with nosebag**

The Belfast Dockers' and Carters' Strike of 1907 was one of the bitterest industrial disputes in the city's history. The strike began in May among the city's dockers, who demanded union recognition and improved working conditions. Carters moved the bulk of goods from the docks by horse and cart. In late June, carters at the Fleetwood Quay, Belfast, came out in sympathy with the dockers and the strike quickly spread among the the rest of the city's 1,500 carters, who also demanded union recognition, shorter hours, and higher pay. The Belfast docks were virtually paralysed, with grain and coal boats, in particular, unable to unload their cargoes. Picketing and allegations of violence against blacklegs led to the army being brought in to back up the police. In August 1907 soldiers reacted to rioting on the Falls Road by bayonet charges and firing live ammunition into the crowd. Sectarian divisions created splits between Catholic and Protestant workers, and this, along with the hardship endured by the strikers and their families, led to a return to work in August 1907.

Right: **Horse feeding from nose bag**

Horses feeding from nosebags were common on the streets of Irish cities in the early twentieth century.

> Mr Bloom came round the corner and passed the drooping nags of the hazard.
> …nosebag time…He came nearer and heard a crunching of gilded oats, the gently champing teeth. Their buck eyes regarded him as he went by, amid the sweet oaten reek of horsepiss.[1]

1 Joyce, James op. cit. p.78

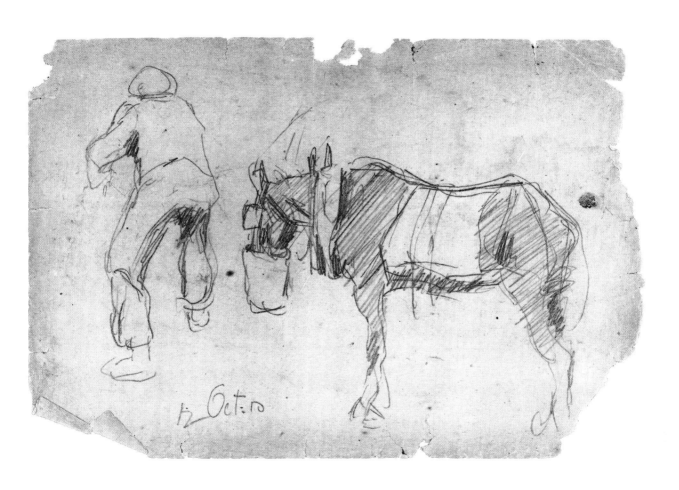

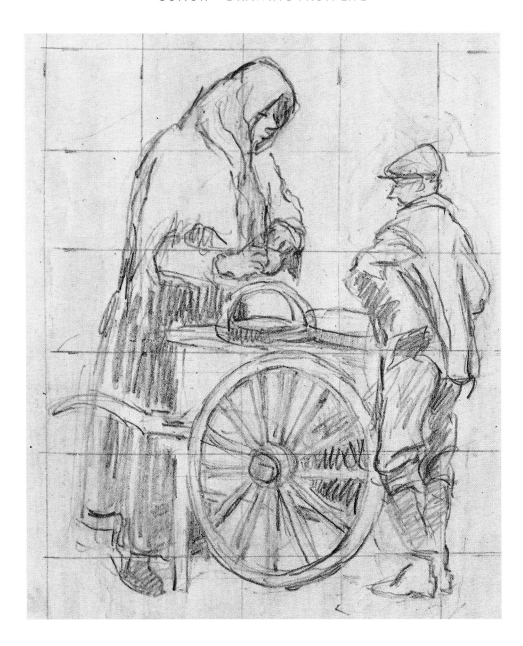

Left: **Woman with handcart and boy**

A variety of food was sold from barrows in early
twentieth-century Belfast; American bacon,
margarine, cheap foreign meat, periwinkles, and until
1908, cockles and mussels. The latter were eaten raw,
and were believed to be one source of the high rate
of typhoid in the city.[1] The control of sewage
discharges into Belfast Lough, and byelaws on the
sale of shellfish from street barrows, were both
responses to a situation in 1906, when Belfast had
the highest level of endemic typhoid in any city in
Britain or Ireland.[2]

1 Gribbon, Sybil op. cit., p.34
2 Collins, Brenda, 'The Edwardian City' in J.C. Beckett et al.
 Belfast, The Making of a City (Belfast: Appletree Press,
 1983 (1988)), p.181

Right: **Crowd round a chip potatoes cart (1918)**

Italian ice-cream, and fish-and-chip shops were opened in Belfast from the turn of the century. By 1914, there were forty-nine. The sale of chips from carts followed as part of this development.[1] Forest Reid recalled one such cart in early twentieth-century Belfast.

[We would] play billiards, and after that sit talking in the smoking room of the Arts Club until the small hours, when we would sally forth in search of Johnston's donkey cart, which was usually to be found at the corner of Chichester Street. From Johnston you could obtain chips and fried fish and poloneys, served in pieces of newspaper. You ate these delicacies in your fingers, for Johnston knew nothing of knives and forks and plates, and you ate them standing there in the street. Johnston's cart was a rallying point for late spirits – mostly youthful toughs…We would stand in a ring round the cart, eating our greasy fish and chips…while the patient donkey dozed and I scratched him under his venerable ears.[2]

1 Gribbon, Sybil op. cit. p.34
2 Reid, Forrest, *Private Road* 1940 pp. 151–152

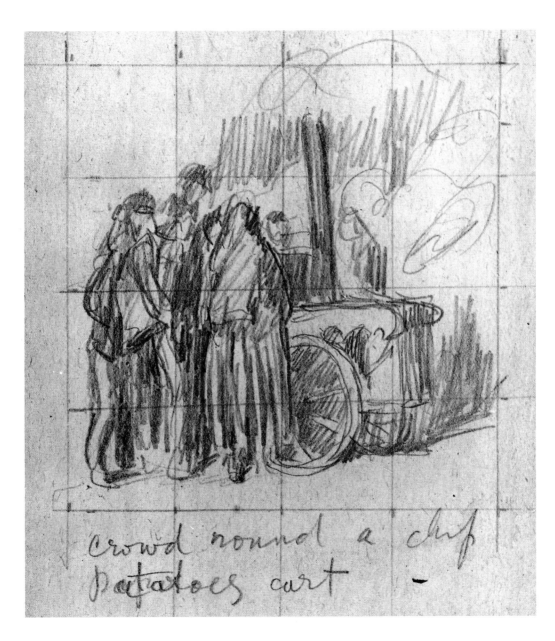

crowd round a chip
potatoes cart

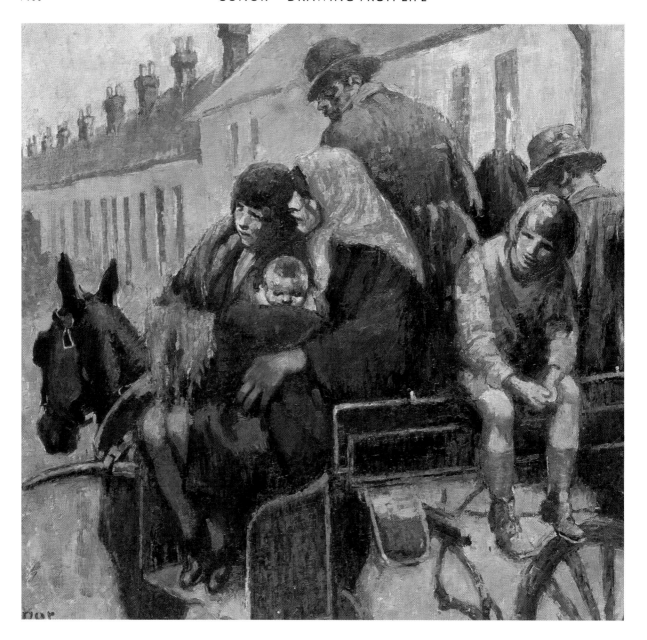

Clothes

Conor drew and painted an industrial world which can appear strikingly modern. Some subjects make us very aware that we are looking at the past, however. Women's clothes in particular, and especially their hats, made elaborate and often dramatic statements about their wearer's position within working-class or bourgeois society. The dullness of men's clothes was partly relieved by military and occupational uniforms.

Left: **The Jaunting car (c.1933)**

The people in the painting are possibly travellers or 'Tinkers'. The painting provides another instance of Conor's approach to social realism.

The jaunting car was a distinctively Irish vehicle, developed from the 'outside car'. It formed the basis of a countrywide passenger service developed by Charles Bianconi, who began his business in Clonmel, County Tipperary, in 1815. By the 1830s, it was had probably become the most popular driving vehicle of its size in Ireland. A jaunting car featured, famously, in the 1950's film *The Quiet Man*, when it carried John Wayne and Maureen O'Hara as they acted out their courtship.

Far left: **Two shawlies with babies**

Left: **Shawlies**

Conor is best known for his paintings of working class women, or 'shawlies', However, only a small number of his surviving drawings show women wearing shawls. It may be an indication of the emphasis of lower middle class people in his drawings that there are more detailed illustrations of women in elegant hats. Conor was, however, emphatic that shawls were much more attractive than hats. In 1929, he expressed his regret at the passing of the use of the shawl. Hats were 'that abomination'. Conor emphasised that he was not advocating a 'dull, ugly, woollen shawl'.

There are countless materials – materials so light and diaphanous that they would be more of an aura to a beautiful head…[The shawl] is also very feminine. After all, is it not in a sense one symbol of motherhood…I like to make crayon sketches of Ulster people in all their walks of life. It was while I was making these that I came across the Ulster mill-lassie in her shawl and realised that this was the headgear most suited to bring out beauty and personality. And these lassies realised it. They did not wear shawls out of necessity but from choice. Even there, however, I fear the ugly talons of modern civilisation have got their grip and girls are falling to the abominable cult of the cloche hat.[1]

1 Wilson, Judith op. cit. p.43

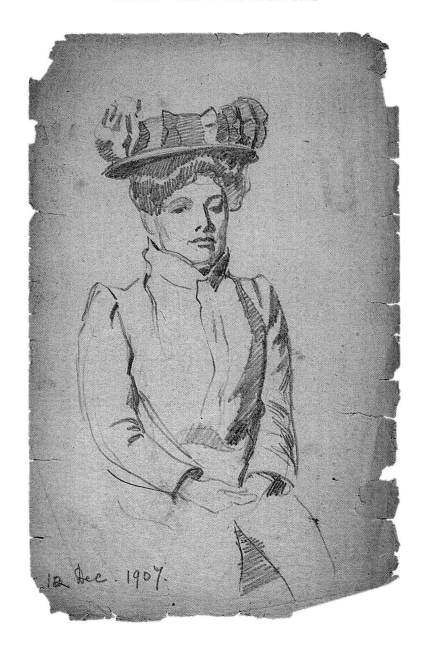

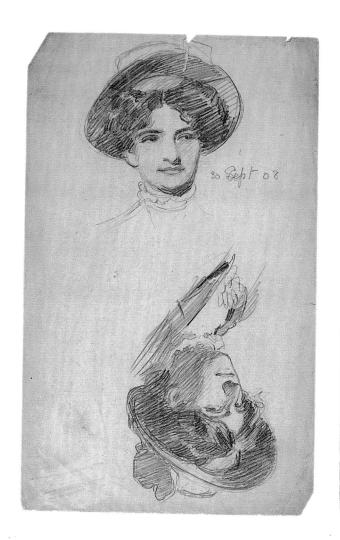

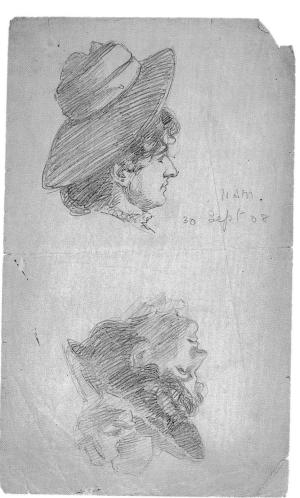

Page 104: **Woman in hat (1907)**

Page 105 Left: **Women in hats (1908)**

Page 105 right: **Women in hats (1908)**

Right: **Woman in hat (1909)**

Conor's dislike of hats seems to have centred on the deep, bowl-like, felt *cloche*, which became fashionable throughout Europe after 1926. His careful drawings of hats in the first decade of the twentieth century, suggests that he appreciated these very much. Pre-war hats tended to have large brims, and sometimes lavish trimmings. They were designed to balance the most common hairstyles of the decade, which tended to have centre partings, soft full waves on each side of the head, with the hair caught up from the nape in a coil or plait. Hats appeared to sit lightly on the head, but were in fact firmly pinned in place. The 1909 drawing, with the elaborate bird on the brim, dramatically illustrates the greater use of feathers as decoration in the period just before the First World War.[1]

1 Amphlett, Hilda, *Hats: A History of Fashion in Headgear* (Chalfont St Giles: Richard Sadler, 1974), pp.156-161

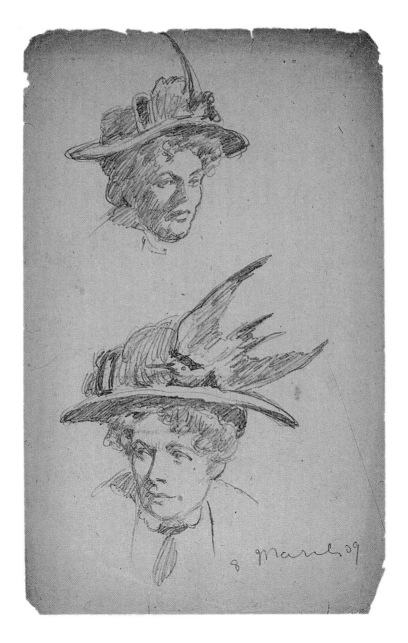

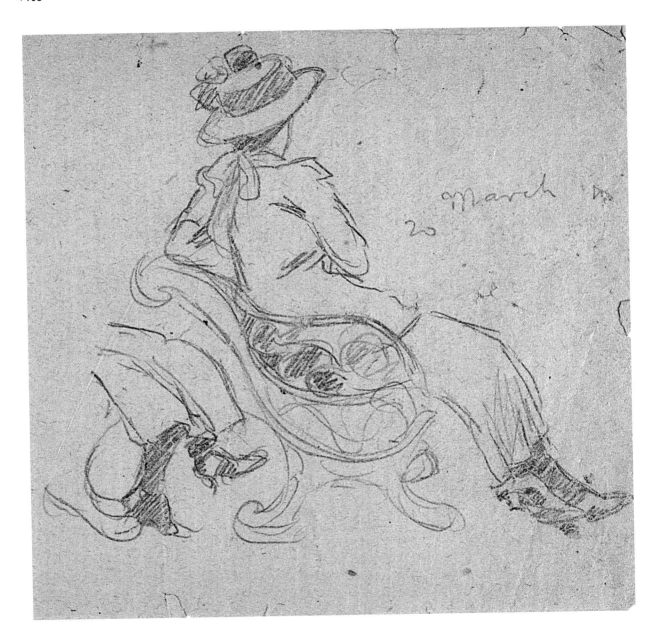

Left: **Woman on park bench (1909)**

This young woman's clothes show the impact of large department stores in making fashions available at affordable prices. It has been claimed that the connection between change in women's dress, and social change was as great in the early twentieth century as at any time in history. Many of the fashions show awareness of women's increasing engagement in active life outside the home. There was a progressive decrease in the amount of volume and underwear worn, while the new comfortable loose waisted jacket, and the straight off the ground skirt, the 'trotteur' spread rapidly from the fashion houses of Paris, throughout most of urban Europe.[1] In Belfast, the number of young women working as clerks doubled between 1901 and 1911, from one to more than 2000. The result was the teenage flapper.

> With screw curls falling from halo hats, uniform blouses and abbreviated skirts boldly displaying their ankles, irrepressible giggles, catch-phrases and knowing winks, they crowded the businessmen's trams and thronged Royal Avenue in the evening.[2]

1 Ewing, Elizabeth *History of Twentieth Century Fashion* (London: Batsford, 1974), pp.65-66
2 Gribbon, Sybil op. cit., p.47

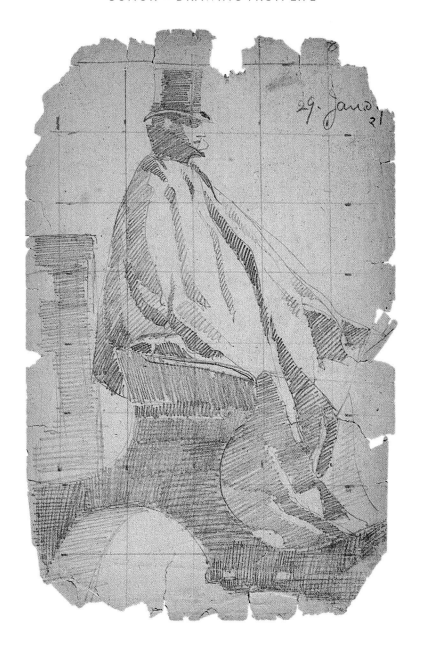

Left: **Coach driver**

The top hat shown in the drawing seems to be a deliberately anachronistic form of dress. Top hats became fashionable during the early nineteenth century, but by the 1840s, they had changed from a fashion to a symbol of urban respectability. The shape of hats varied during the century. By 1900, they were slim, neat and slightly waisted. By this time, they were worn with formal dress by the upper classes.[1] The driver's top hat illustrated here, was probably intended to reflect the social status of his employers.

1 Clark, Fiona, *Hats* (London: Batsford, 1982), pp.40,43

Right: **Man in bowler – reading (?)**

The bowler is a clear instance of the conservatism which has characterised men's dress throughout the last 150 years. All the major hat styles of the twentieth century were developed during the period 1850–1870. The bowler was fashionable by the 1860s, and by the 1880s was seen as respectable headgear for the lower middle classes, the alternative to the top hat worn by the upper classes. The latter continued to wear bowlers also, however. They were, for example, made part of regulation 'mufti', or civilian dress, for British Guards Officers in the late 1940s.[1] In Ulster, the fashion was given an even longer life span, when it became part of common dress worn by members of the Orange order, during parades.

1 Clark, Fiona, op.cit., pp. 42 and 66

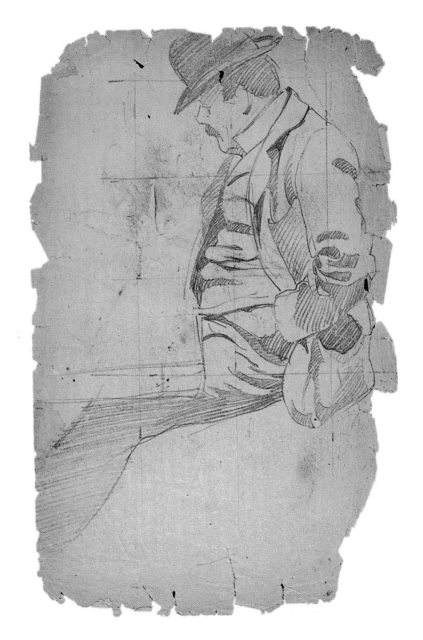

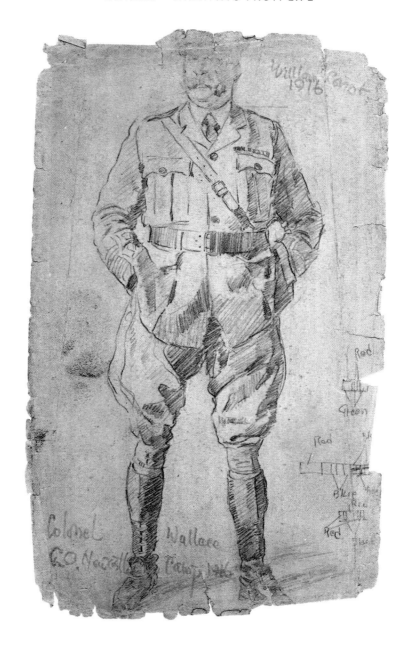

Left: **Colonel Wallace (1916)**

The Colonel commanded the South Down Militia in the South African War. During the First World War he was in charge of recruitment to the regiment. His daughter, Caroline Mabel 'Roguie' Wallace told family members that the Colonel had found Conor 'in the gutter' around 1915, and had brought him to stay at the family home, Myra Castle, off and on for about two years. During this time, Conor produced a series of portraits of the Colonel's officers at Donard Lodge Camp. Colonel Wallace died in 1929.

Right: **Hu Robert Wallace (1917)**

This drawing was made during the period in which
Conor worked in and around Myra Castle under the
patronage of Colonel Wallace. Hu was the son of the
Colonel, and at the time the drawing was made, he
was a pupil at Harrow. He became a solicitor in
Dublin, but sailed home to Strangford at weekends.
He died at the age of 31, during one of these trips,
when he drowned near Carlingford Lough, in
June 1930.

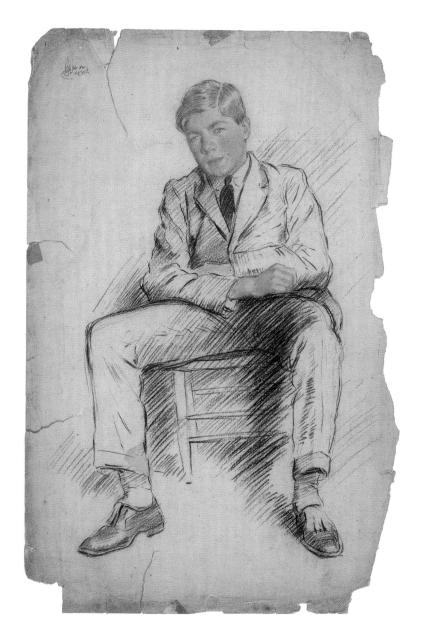

Bibliographical References

Allen, W.E.D. *David Allens: The History of a Family Firm 1857 – 1957* (London: Murray, 1957)

Amphlett, Hilda *Hats: A History of Fashion in Headgear* (Chalfont St Giles: Richard Sadler, 1974)

BBC The Arts in Ulster Broadcast of NIHS, 18.05.61

BBC 19/140U676. Broadcast 17.05.1981

Bardon, Jonathan *Belfast: An Illustrated History* (Belfast: Appletree, 1982(1983))

Belfast and Province of Ulster Directory (Belfast: Publishing Office, 1909)

Bigger, Francis Joseph *Labourers' Cottages for Ireland* (Dublin: Independent Newspapers, 1907)

Brewer's Dictionary of Phrase and Fable (London: Cassell, 1870 (1985))

Clark, Fiona *Hats* (London: Batsford, 1982)

Collins, Brenda 'The Edwardian City' J.C. Beckett et al *Belfast, The Making of a City* (Belfast: Appletree, 1983(1988))

Dunhill, Alfred *The Pipe Book* (London: Booker, 1969)

Eliot, T.S. 'Portrait of a Lady' *Collected Poems* (Faber and Faber, 1954 (1972))

Ewing, Elizabeth *History of Twentieth Century Fashion* (London: Batsford, 1974)

Friers, Rowel Radio interview (BBC 19/14 OU676 Broadcast 17.05.1981)

Gribbon, Sybil *Edwardian Belfast: A Social Profile* (Belfast: Appletree Press, 1982)

Heaney, Seamus 'The Sense of the Past' *History Ireland*, Spring 1993 issue, p.33

Hewitt, John *Art in Ulster: 1* (Belfast: The Blackstaff Press, 1971)

Hewitt, John *The Collected Poems of John Hewitt* ed. F. Ormsby (Belfast: The Blackstaff Press, 1991)

Jamison, Kenneth 'Painting and Sculpture' in *Causeway: The Arts in Ulster* ed. M. Longley (Belfast: Arts Council of Northern Ireland, 1971), p.44

Joyce, James *Ulysses* (Harmondsworth: Penguin, 1922 (1968))

Kennedy, Brian P. *Irish Painting* (Dublin: Town House, 1993)

McBride, Jack *Traveller in the Glens* (Belfast: Appletree Press, 1979)

Macgill, Patrick *Children of the Dead End* (Jenkins: London, 1914), p.77

MacManus, Megan 'The Functions of Small Ulster Settlements' *Ulster Folklife* vol.39 (Holywood, 1993)

Ó Lochlainn, Colm *The Complete Irish Street Ballads* (Pan: London, 1939 (1984))

Patton, Marcus *Central Belfast: A Historical Gazetteer* (Belfast: Ulster Architectural Heritage Society, 1993)

Reid, Forrest *Private Road* (1940), pp. 151–152

Valleley, Fintan (ed.) *The Companion to Irish Traditional Music* (Cork: Cork University Press, 1999)

Wilson, Judith *Conor: The Life and Work of an Ulster Artist* (Belfast: The Blackstaff Press, 1977)

Winchester, Simon, quoted in Singleton, D. A. 'Belfast: Housing Policy and Trends' in *Province, City and People* eds. R. H. Buchanan and B.M. Walker (Antrim: Greystone Books, 1987), p.151

Suggested Further Reading

Bardon, Jonathan, *A History of Ulster* (Belfast: The Blackstaff Press, 1992)

Bardon, Jonathan and Burnett, David, *Belfast, A Pocket History* (Belfast: The Blackstaff Press, 1996)

Beckett, J.C. et al, *Belfast, The Making of the City* 1880-1914 (Belfast: Appletree Press, 1988)

Boylan, Henry (ed), *A Dictionary of Irish Biography* (3rd edn) (Dublin: Gill & Macmillan, 1999)

Byrne, Art and McMahon, Sean, *Great Northerners* (Dublin: Poolbeg, 1991)

Craig, Patricia, *The Belfast Anthology* (Belfast: The Blackstaff Press, 1999)

Elliott, Sydney and Flackes, W.D., *Northern Ireland A Political Directory* 1968-1999 (Belfast: The Blackstaff Press, 1999)

Erskine, J. and Lucy, G., *Cultural Traditions in Northern Ireland* (Belfast: The Institute of Irish Studies, 1997)

Fallon, Brian, *Irish Art 1830-1990* (Belfast: Appletree Press, 1994)

Hamilton, Paul, *Up the Shankill* (Belfast: The Blackstaff Press, 1979)

Holmes, Finlay, *Our Presbyterian Heritage* (Belfast: Publications Committee of the Presbyterian Church in Ireland, 1985)

Ireland Yearbook, *The, Paintings from the Ulster Museum, 1995, 1996, 1997, 2000, 2001, 2002* (Belfast: Appletree Press, 1995, 1996, 1997, 2000, 2001, 2002)

Larmour, Paul, *Belfast, An Illustrated Architectural Guide* (Belfast: Friar's Bush Press, 1987)

Law, Gary, *The Cultural Traditions Dictionary* (Belfast: The Blackstaff Press, 1998)

Maguire, W.A., *Belfast – A History* (Keele: Ryburn Publishing/Keele Univeristy Press)

Newmann, Kate, *Dictionary of Ulster Biography* (Belfast: The Institute of Irish Studies, 1993)

Owen, D. J., *A History of Belfast* (Belfast: W & G Baird)

Sweetman, Robin and Nimmons, Cecil, *Port of Belfast, 1785-1985* (Belfast: Belfast Harbour Commissioners, 1985)

Templeton, George E. and Weatherall, Norman, *Images of Ireland, South Belfast* (Dublin: Gill & Macmillan, 1998)

Walker, Brian Mercer, *Faces of the Past, A Photographic and Literary Record of Ulster Life 1880-1915* (Belfast: Appletree Press, 1974, 1999)

Walker, Brian, *No Mean City* (Belfast: Friars Bush Press, 1983)

Below: **Man washing hands (see p.51)**

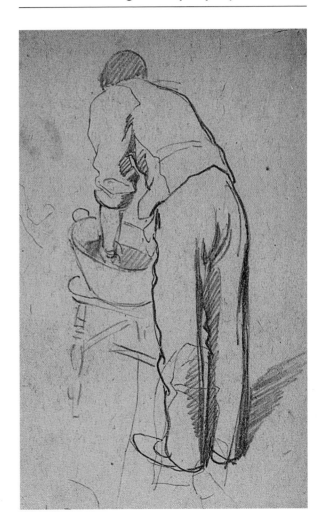

Index

Index compiled by Paul Harron

Acknowledgements

A LOT OF people helped with this book, and I would like to thank at least some of them. Curatorial colleagues at Cultra who contributed their expertise included Fionnuala Carragher, Valerie Wilson, Mark Kennedy, Robbie Hannan, and Mervyn Watson. Ken Anderson and Alan McCartney of the Museum's Photographic staff were their usual helpful selves, as were Stores and Conservation staff. Hazel Bruce and Arlene Bell of the Education Department have backed the project with moral support and practical help. Michael Donnelly and Ray Gillespie have also been very helpful – Michael suggested the book's title. Gráinne Loughran advised on the BBC archives, and Maureen Paige was a secretarial tower of strength as usual.

Help from outside the Museum was of vital importance. David Good provided family history behind the Wallace portrait drawings. Philip Flanagan gave an artist's view of the drawings, while fresh insights into Conor's life and work were given with great generosity by T. P. Flanagan, and Kenneth Jamison, both authorities of international stature, who also knew Conor personally.

Right: **Washing the doorstep**

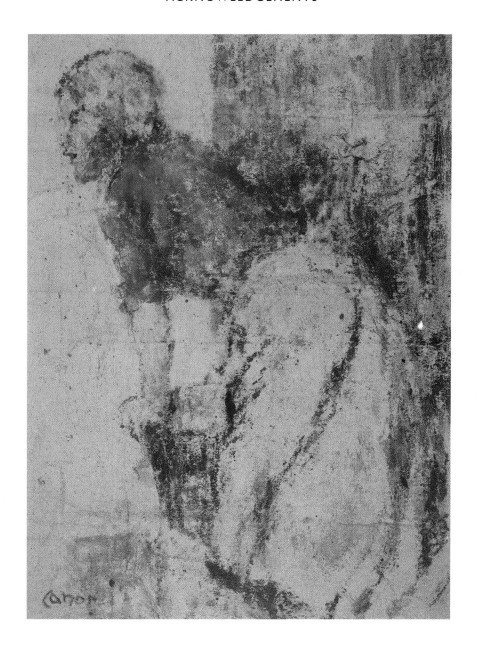